For Wynne,

In celebration of the
art and the spirit in all
of life, with very good
wishes,

Susan Seddon Boulet

1993

SHAMAN

SHAMAN

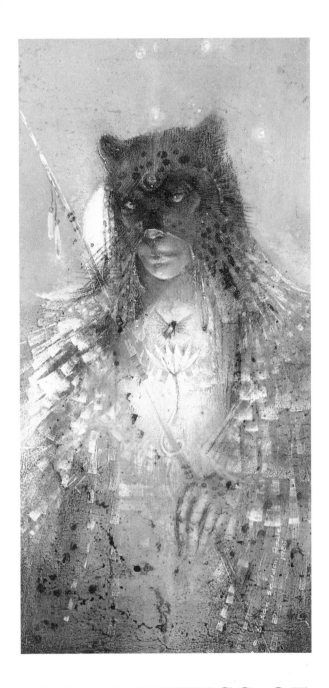

THE PAINTINGS OF
SUSAN SEDDON BOULET

Pomegranate Artbooks ■ **San Francisco**

Dedication

To my son, Eric, for Kathy
and Marita, who started me
painting "seriously", my
family and to my good and
loyal friends who have stood
by me in the last nine growing
and changing years and with
love, strength and humor
have supported the work that
makes up this book; to
Angeles, who has opened so
many new doors: and to
Larry, without whom this
project might never have
happened.

—S.S.B.

Pomegranate Calendars & Books
Box 6099
Rohnert Park, CA 94927

Text ©1989 Pomegranate Calendars
 & Books
Paintings ©1989 Susan Seddon Boulet

ISBN 0-87654-433-2
Library of Congress Catalog Number 88-64077
Pomegranate Catalog Number A526

Designed by Bonnie Smetts Design
Printed in Korea

These figures are out of our dreams, those which flee from us upon awakening, those which are dispersed like dew at dawn, those which fall apart between our fingers like dust-roses.

Susan Boulet has a more muted step, or perhaps she is invisible and more soft-voiced, soft-gestured, as the images do not escape from her. She can return from her voyages with intact descriptions, with the elusive profiles of our prophets, our fairytale lovers, our story-tellers, our personages from a thousand and one nights, from medieval forests only known to unicorns, from places never visited by us but which we remember.

Susan Boulet is the alchemist who loves gold as a symbol of transcendence, who saw fish with bird's wings, warriors with peacock profiles, the unicorn himself transporting a kid-napped princess. She captures the spirits who dance in the sun's rays. We always did want to see the spirit of a tree. Susan did. She brings us every detail of leaf and finger intertwined, eyes and roots not visible to human eyes. The holy family so frozen; in our holy books beam three radiant faces within one egg. Neptune is guarded by a sea-horse, the medieval princess wears a peaked veil like a rain of gold, as fragile as a mayfly.

Susan has her own mythology; it is of the elements which haunt our childhood and persist in our dreams. In her world all events, animals, people, flowers, and costumes are iridescent. Lovers are intertwined like lianas, some of the figures levitate, others are bathed in sunrays. She invents flowers with eyes and ears, colors not in our daily palette. Her world is a rich, fecund one, an evanescent world usually eluding us, now in our possession.

by Anaïs Nin

The world before me is restored in beauty.

The world behind me is restored in beauty.

The world below me is restored in beauty.

The world above me is restored in beauty.

All things around me are restored in beauty.

My voice is restored in beauty.

It is finished in beauty.

It is finished in beauty.

It is finished in beauty.

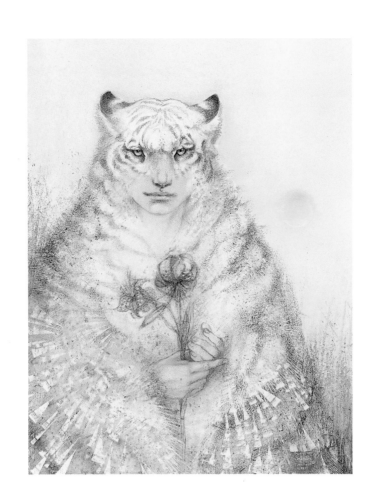

ACKNOWLEDGEMENTS

The editors wish to thank Timothy White, editor-in-chief of *Shaman's Drum*, whose early sighting of the emerging shamanic nature of Susan Seddon Boulet's recent paintings has led directly to this publication. We extend a grateful and warm handshake to James Swan, the editor of Susan's annual calendar *The Path of the Shaman*, for his diligent work in gathering together the quotations that appear throughout this book, poised in harmony with Susan's paintings. To the spirit of Anaïs Nin, thank you for the enthusiastic appreciation of Susan's work which graces our opening pages. (Although Anaïs Nin authored this piece during an earlier period in Susan's career, we have chosen not to edit it.) To Susan Seddon Boulet, thank you for fifteen years of unshakeable faith in Pomegranate.

INTRODUCTION

The origins of shamanism predate recorded civilizations and lie beyond protohistory. Evidence of shamanic practices exists from the Paleolithic period, tens of thousands of years ago. The wellspring of shamanism may in fact be the rise of consciousness itself and could be inextricably bound to the necessarily first urge of consciousness, to explain itself.

Shamanism appears to have been a world religion, in the broadest sense. Its practice was shared by all indigenous peoples, with an underlying cosmography that cut across and through local customs, labeling systems and manifestations peculiar to regional biota. Even today, when long in retreat from the relentless onslaught of western rationalism and insensate technology, shamanism survives in native cultures on all of the planet's inhabited continents.

Shamanic belief in an underworld and in an ``upper'' world, with ordinary reality balanced precariously in between, bears a striking resemblance to western religion, with its layering of heaven, earth and hell. Its world of good spirits, guardian spirits and evil spirits can be more than casually compared to the western litany of archangels, guardian angels, patron saints and the devil. Does any historical priesthood, whether of the pharaoh's times or of Luther's, with its claimed ability to intercede with the spiritual world on behalf of its flock, differ greatly from the role of the shaman?

The divergence of western religions from shamanism lies in the concepts of humans as the exclusive possessors of spiritual souls and in humankind as the lone interpreter of ordinary and extraordinary realities. Shamanic peoples are neither so audacious nor, perhaps, so foolish.

In shamanism all of existence is viewed as highly integrated. Literally, whatever exists has a soul. There is no division into organic and inorganic. There is no hierarchical structuring of consciousness with humankind comfortably ensconced at the top and ending with rocks at the bottom. All realities exist in simultaneous time. All forms of existence are to be recognized and respected and, in turn, are to respect and recognize the observer.

The role of the shaman rises out of a recognition, seemingly long lost to modern humankind, of humanity as disruption. In making its way, humankind, in killing for food, clothing and shelter, brings disorder where there was none. There is a subtlety here equal to that of the story of Eden.

To the shaman falls the task of righting the wrongs, of appeasing the offended, of repairing the harm his/her people bring upon themselves through both unavoidable as well as intemperate and disrespectful action. In considering the shaman as healer, as restorer of balance, it is not farfetched to think of him/her as an environmentalist or even as an ecologist of the group psyche.

Central to all shamanic practices is the journey out of ordinary reality. The power gained from experiencing other realms of consciousness is the power used to heal. Such a journey is not easily accomplished or casually undertaken. Shamans employ a varying body of techniques (rhythmic, incessant drumming and psychoactive drugs, for example) to free themselves of the tenacious clutches of ordinary reality. (Buddhist practice as well as the tradition of the western contemplative share this understanding of the need to empty the mind before the ecstatic journey can begin.)

The geography of shamanic journeys is fascinating and involves, for voyages to the upper world, sacred sites, usually mountaintops or other high elevations or magic trees (similar in some respects to the Buddha's Bodhi Tree); voyages to the underworld invariably are described as voyages through an elusive opening, often at the end of a long constricted passage or tunnel. Such journeys are always difficult. The path is often frightening, especially so in encounters with the souls of the dead and with evil spirits. To be in fear of his/her own life is no uncommon experience for the shaman. That these journeys are purposeful acts of will is the essence of the shaman.

To reach the window into alternate realities the shaman will benefit from guides and allies, almost always in the form of animal spirits. Perhaps it will be the jaguar who, appearing at the shaman's side, will lead him/her through the labyrinth, or the owl, who will position itself as a directional post. Perhaps the eagle will spread its wings, offer its broad back and fly the shaman through the last leg of the journey.

It is in attempts to describe these shamanic experiences that words begin to fail and the use of symbols rises as an alternate vehicle. This book is not a book of words, but a book of interrelated paintings. In the spirit of shamans being men and women of few words and in understanding Joseph Campbell's dictum that the spiritual, ecstatic and mysterious is approachable only through art, we offer you this volume of Susan Seddon Boulet's paintings.

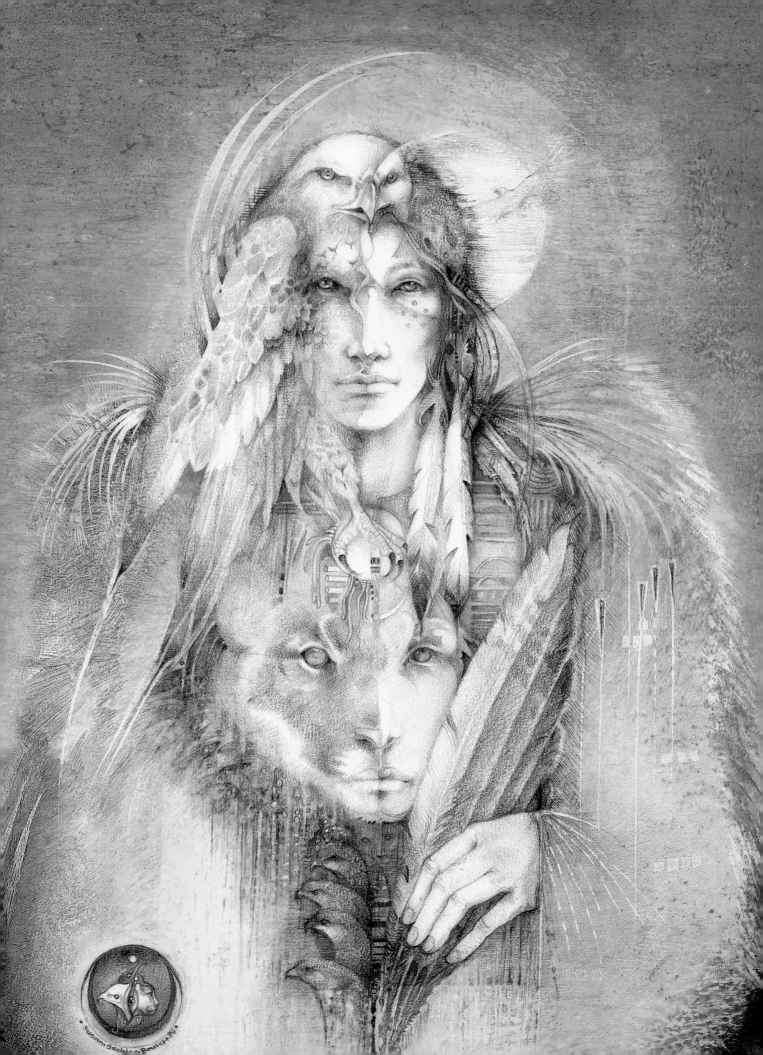

After our moon mother,

At her sacred place,

Still small, appeared,

And now yonder in the east

Standing fully grown makes her days,

Now our spring children,

Whoever truly desires in his heart to grow old,

Taking prayer meal,

Taking shell,

Taking corn pollen,

Yonder with prayers

One by one shall make their roads go forth.

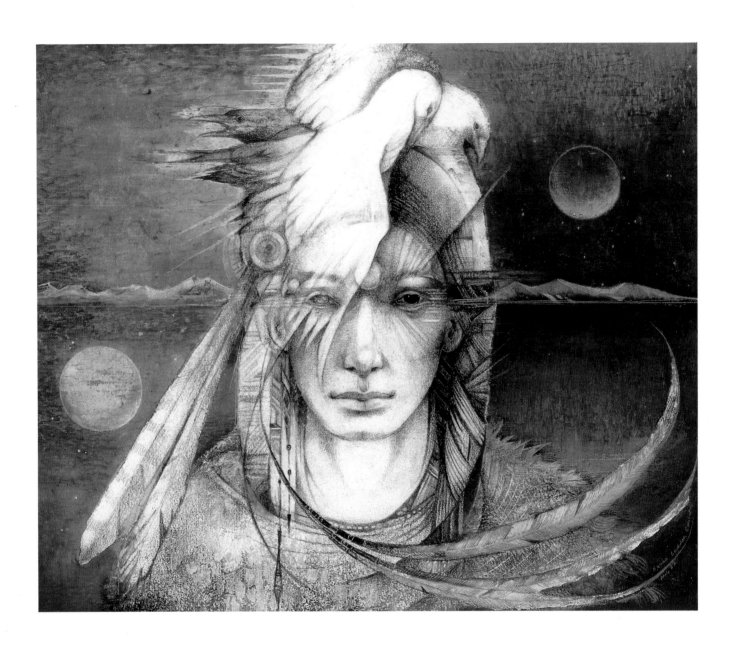

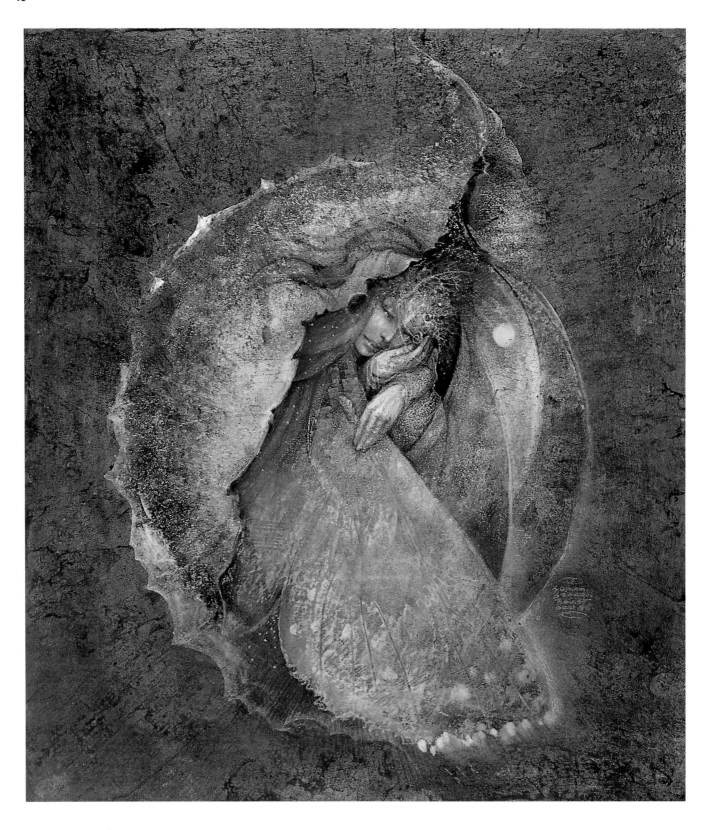

Crisa'lida

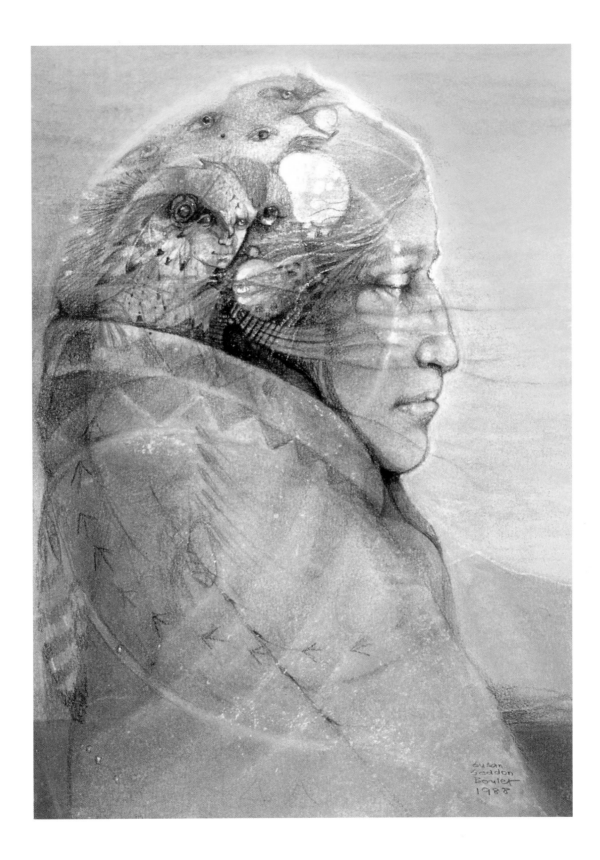

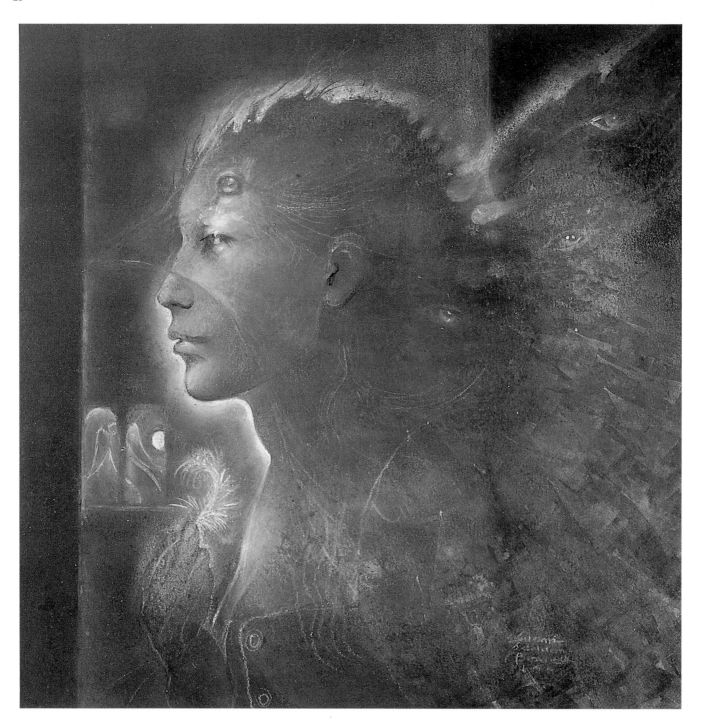

Sometimes dreams are wiser than waking.

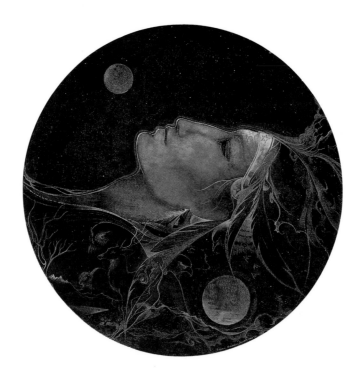

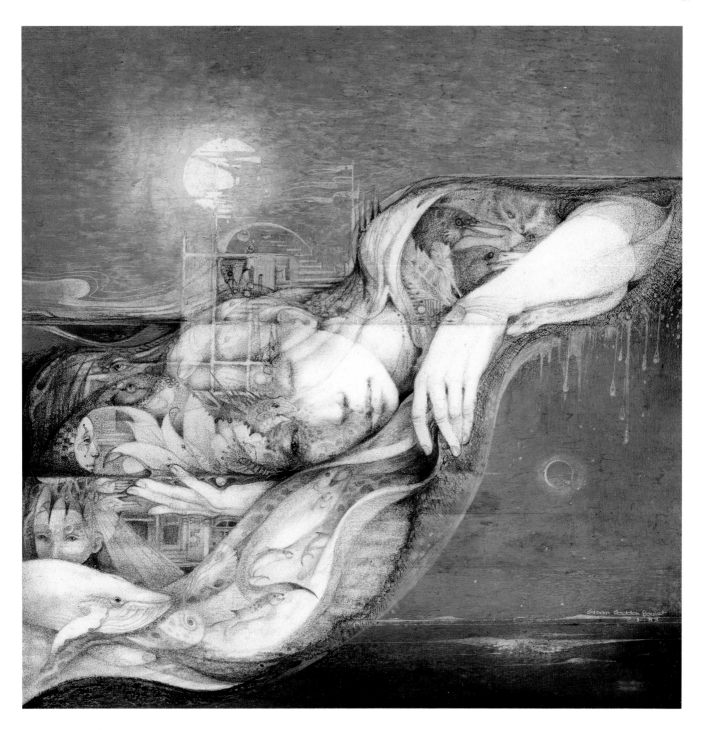

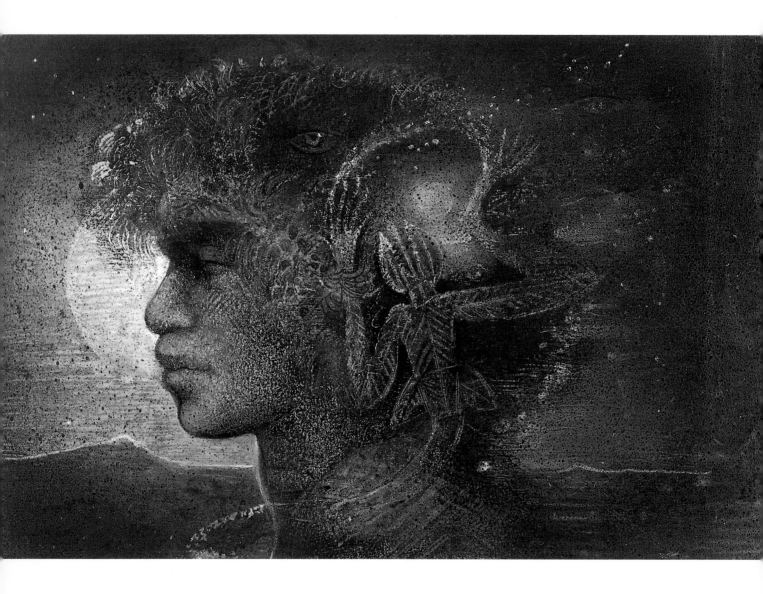

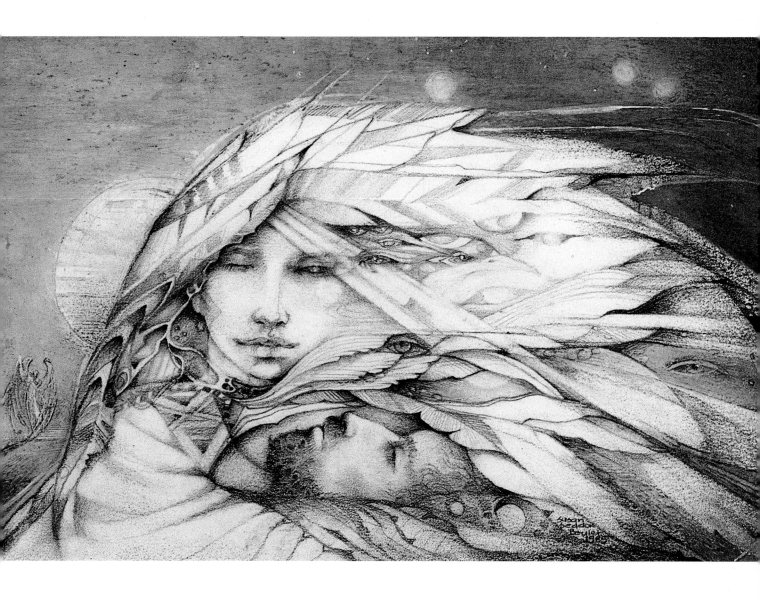

Annunciation

Spirit
making a passage
for himself

Spirit
making a breath
for himself

out of me
out of me

he sprang from the ground
everyone saw him
he sprang from the earth
everyone saw him

Spirit
making a passage
for himself

Spirit
making a breath
for himself

out of me
out of me

he sprang from the ground
there between the houses
he sprang from the earth
there between the houses

Spirit
making a passage
for himself

Spirit
making a breath
for himself

out of me
out of me

here on the outside
everyone saw him
he looked back at them
everyone saw him

Spirit
making a passage
for himself

Spirit
making a breath
for himself

out of me
out of me

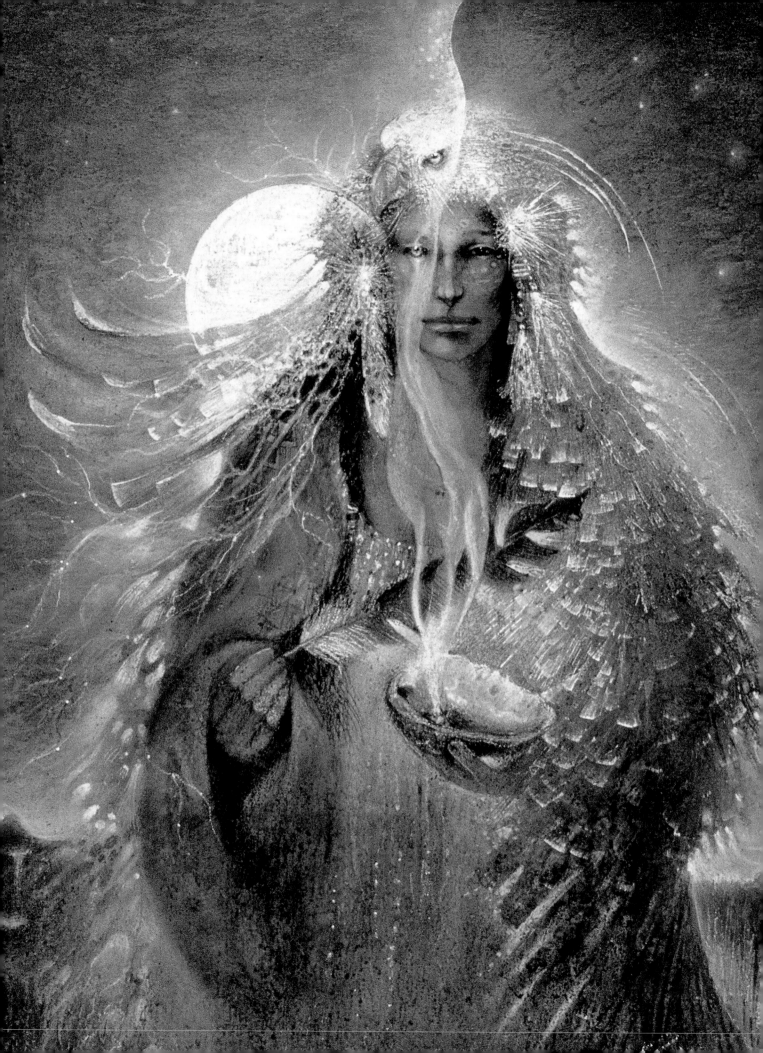

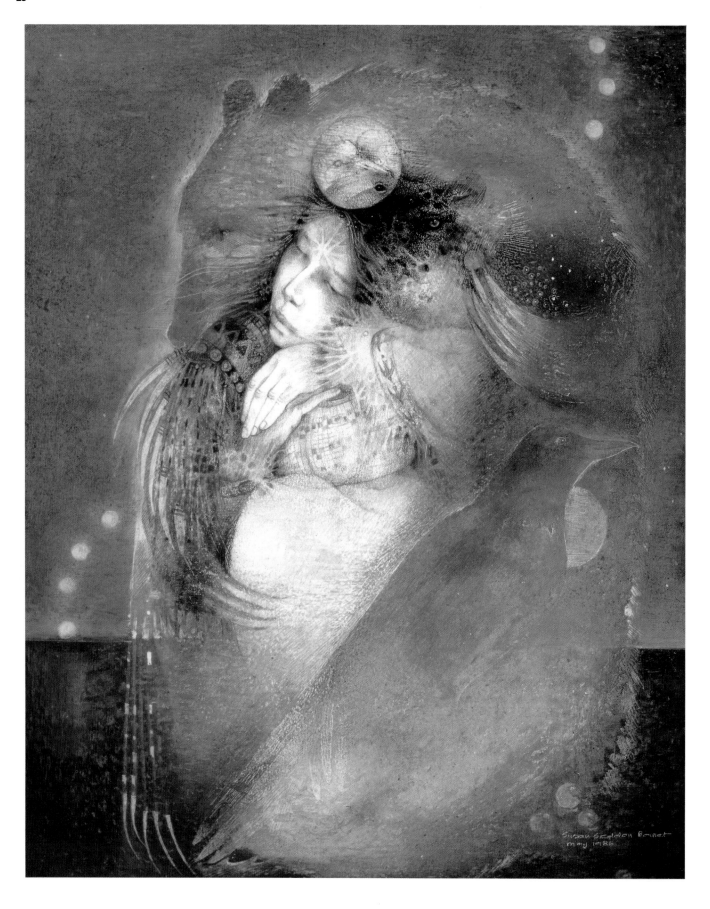

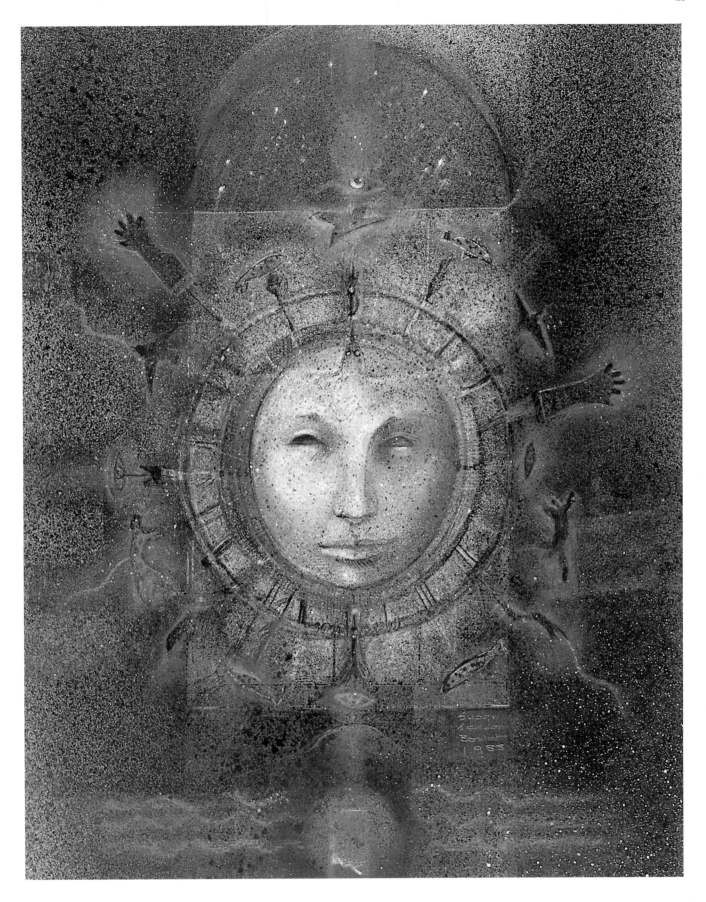

Ritual Mask

In the house of life I wander

On the pollen path,

With a god of cloud I wander

To a holy place.

With a god ahead I wander

And a god behind.

In the house of life I wander

On the pollen path.

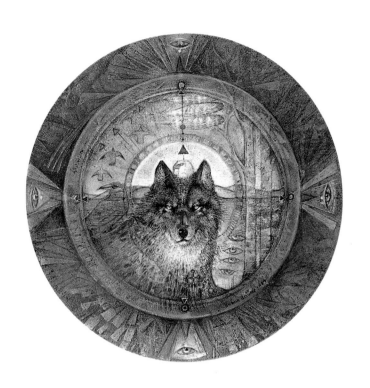

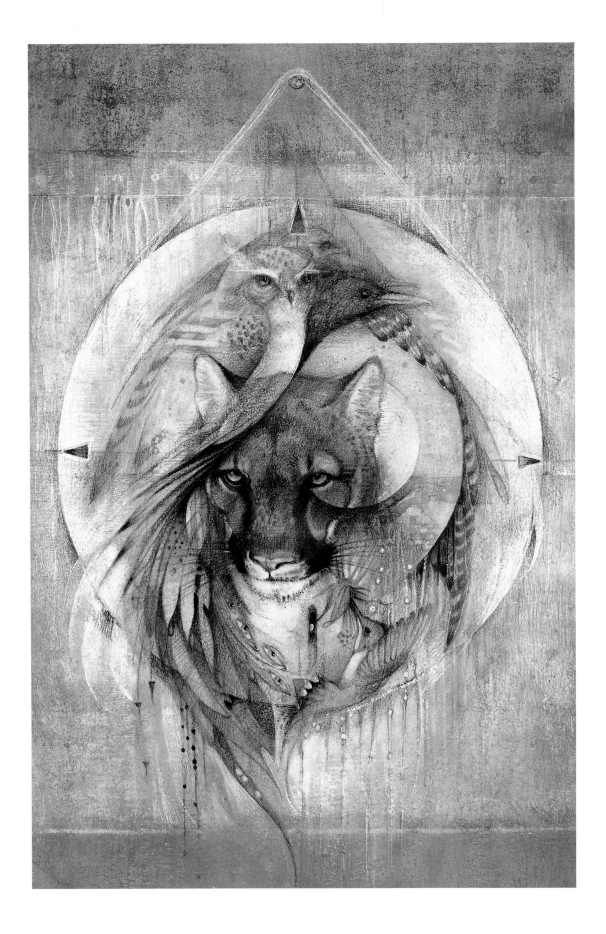

Moon Shield

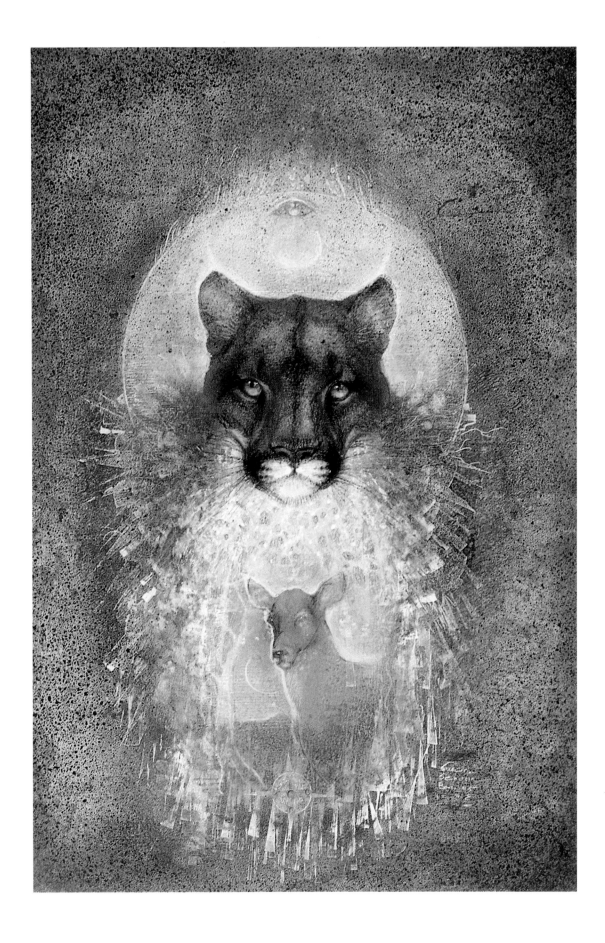

Puma Shield

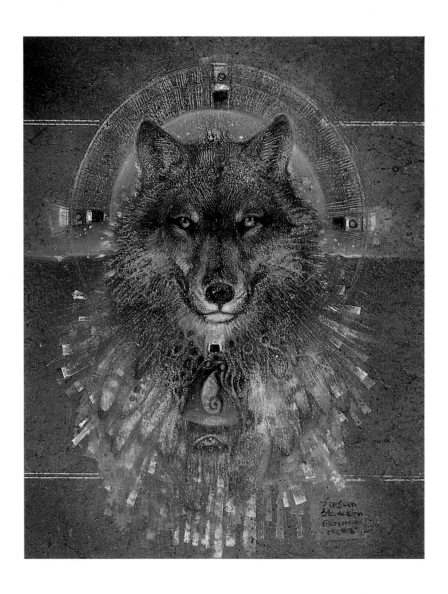

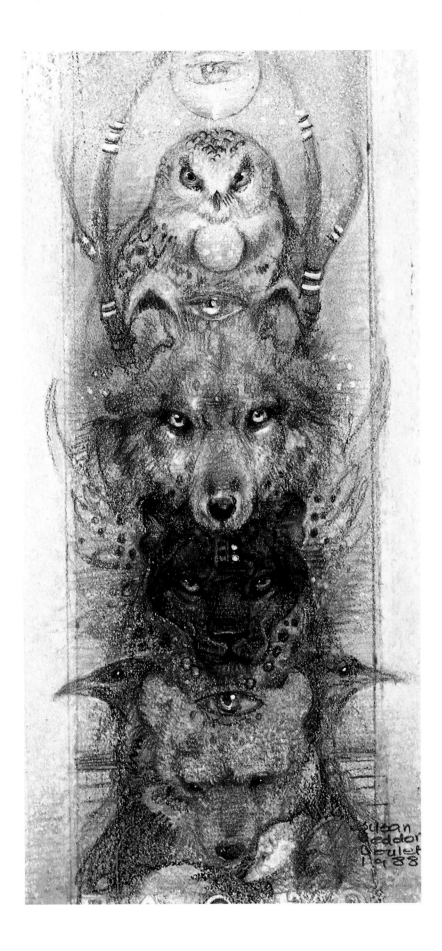

Totem

In the beginning of all things,
wisdom and knowledge were
with the animals; for Tirawa,
the One Above, did not speak
directly to man. He sent certain
animals to tell men that he
showed himself through the
beasts, and that from them,
and from the stars and the sun
and the moon, man should learn.
Tirawa spoke to man through
his works.

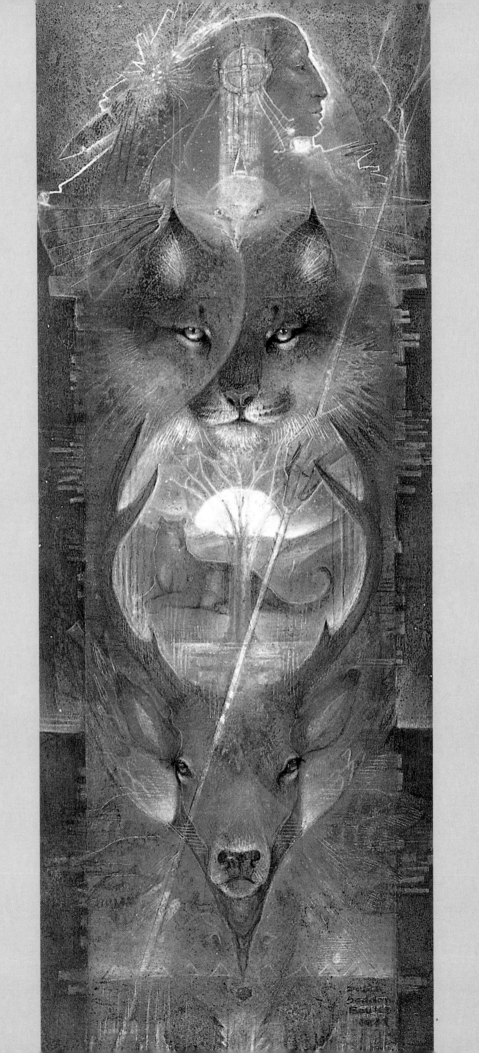

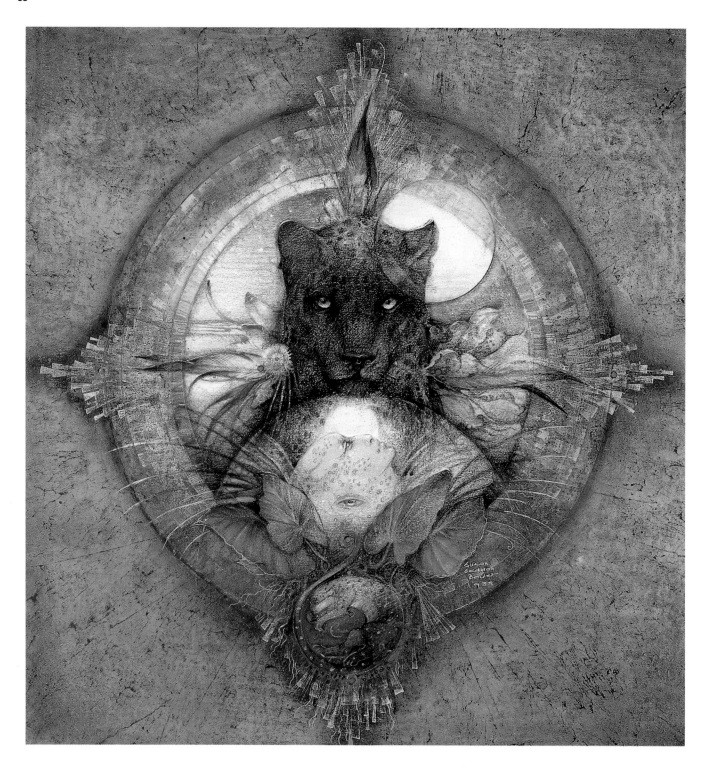

Jaguar Legend

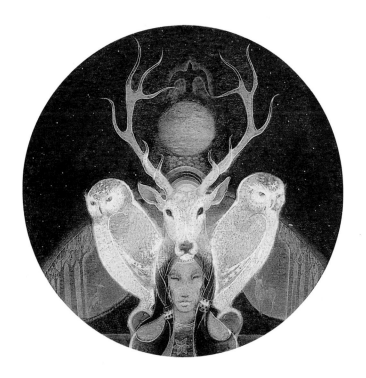

Dream Shaman

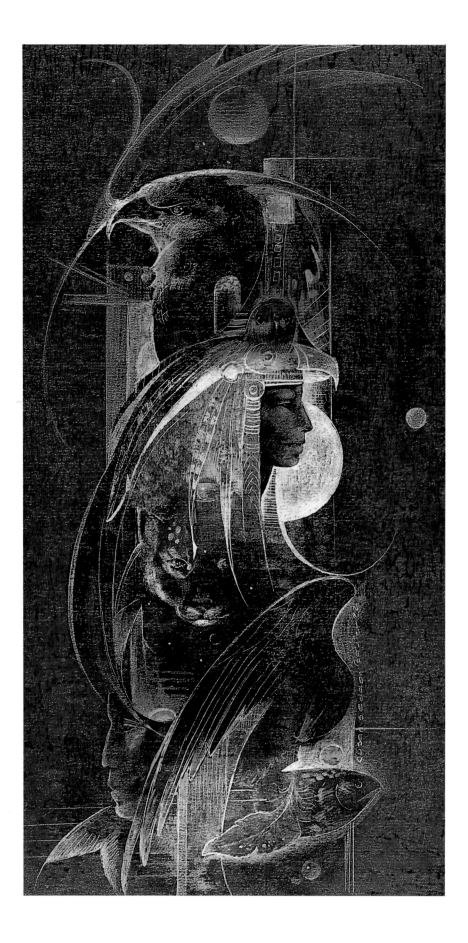

Eye of the Puma

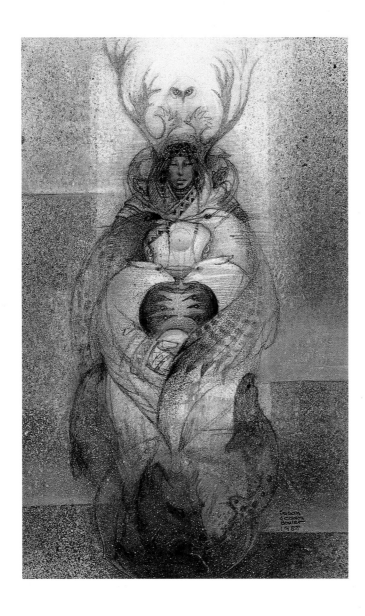

To the center of the world you have taken me (Great Spirit) and showed me the goodness and the beauty and the strangeness of the greening earth, the only mother—and there the spirit shapes of things, as they should be, you have shown me and I have seen.

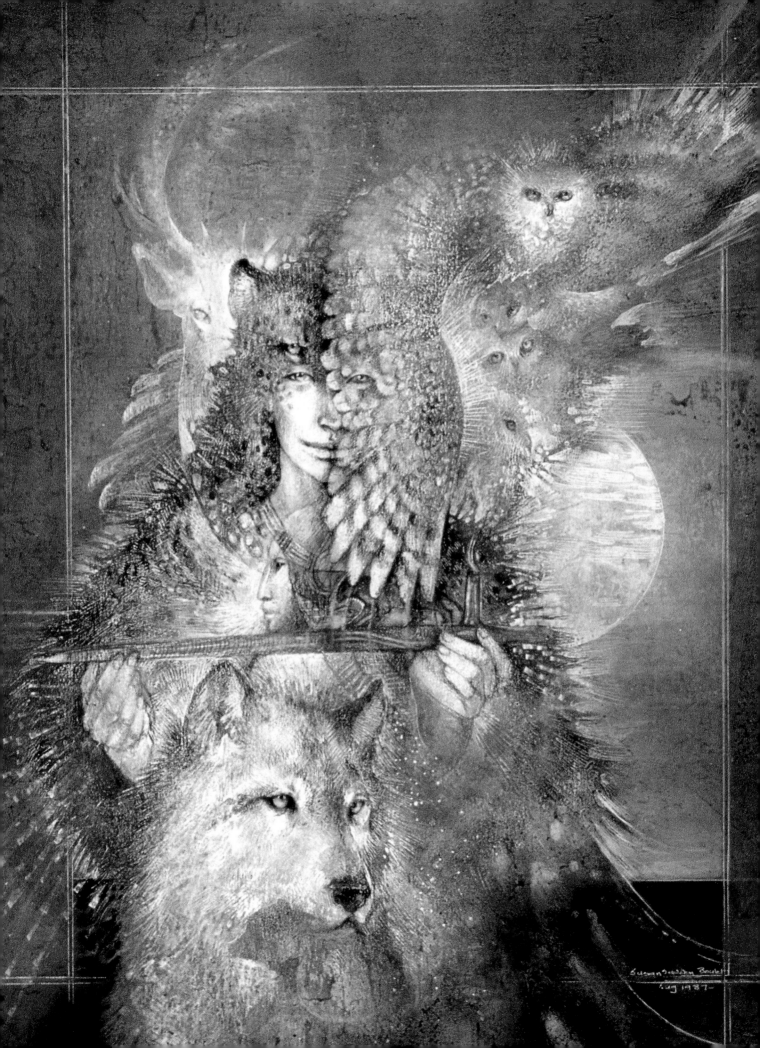

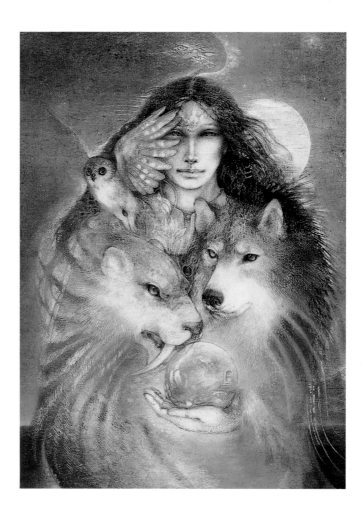

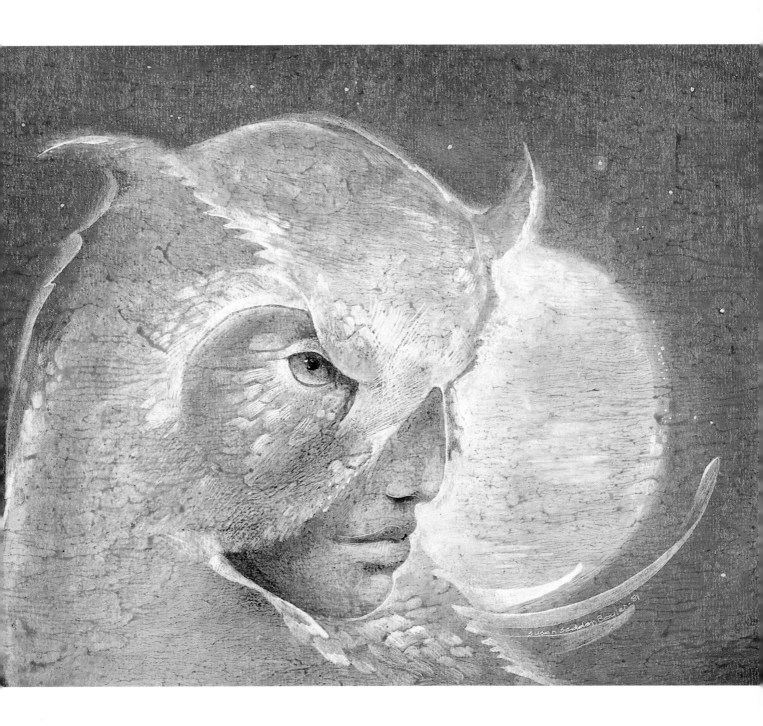

Shaman

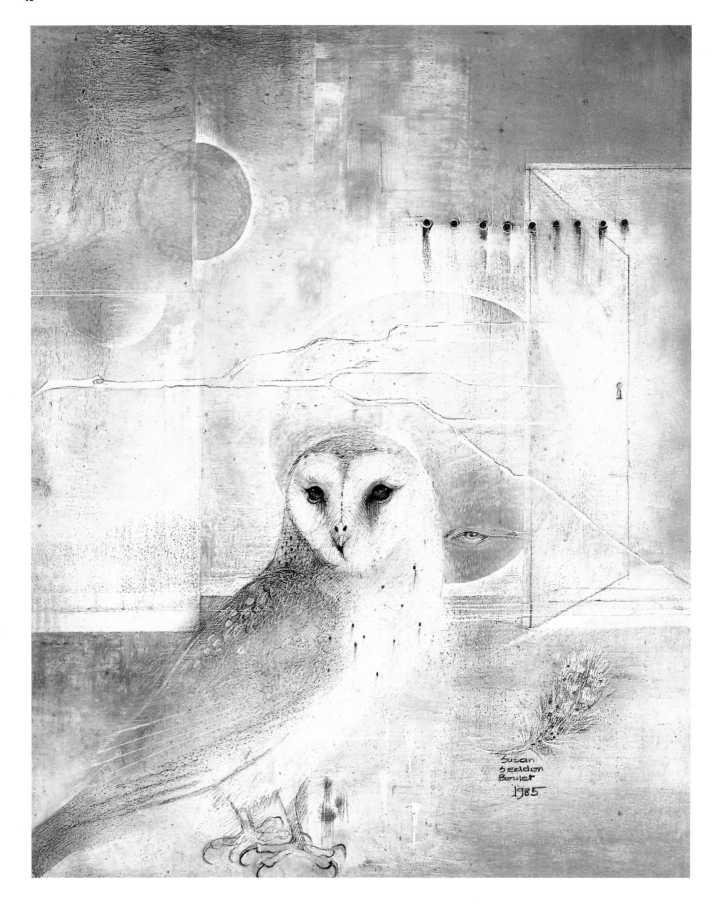

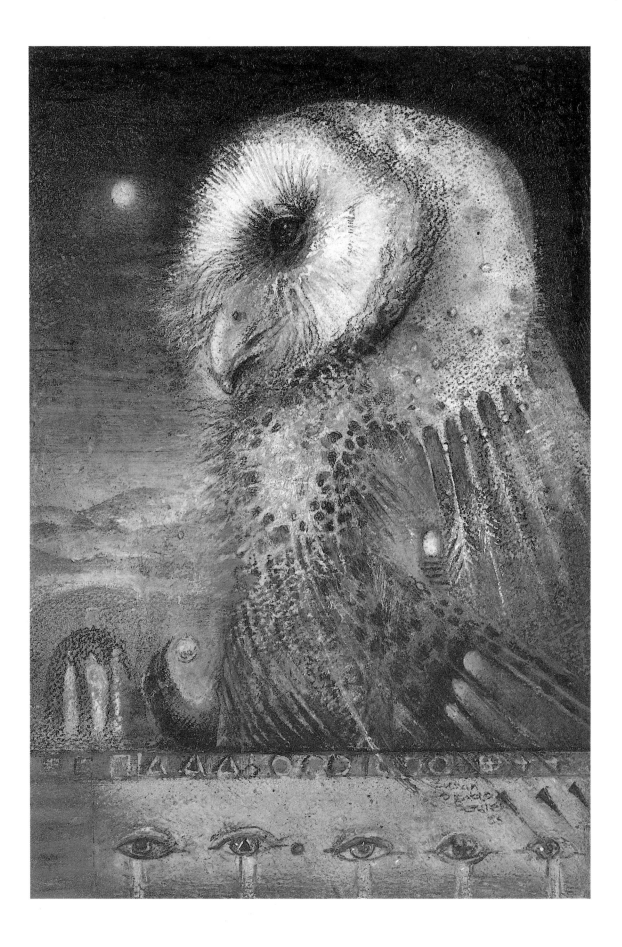

Keeper of the Mysteries

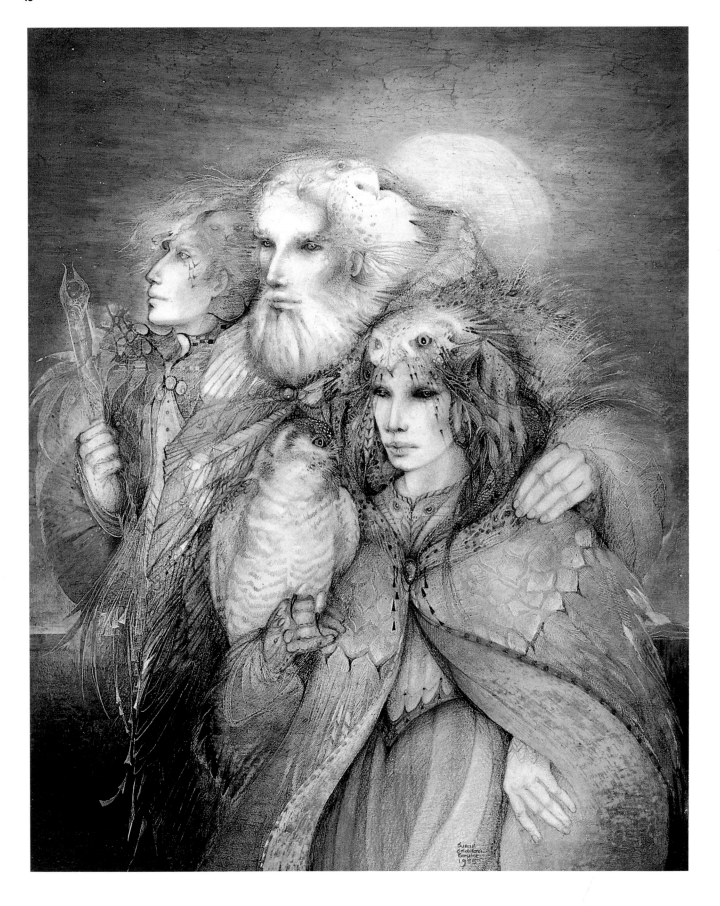

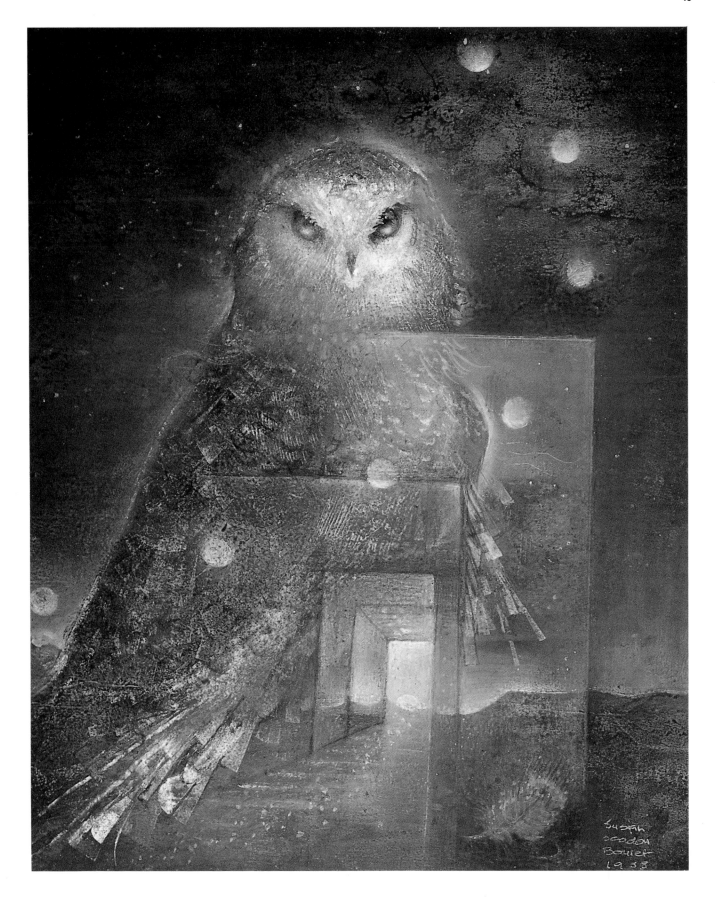

Heaven and earth determine the places. The holy sages fulfill the possibilities of the places. Through the thoughts of men and the thoughts of spirits, the people are enabled to participate in these possibilities.

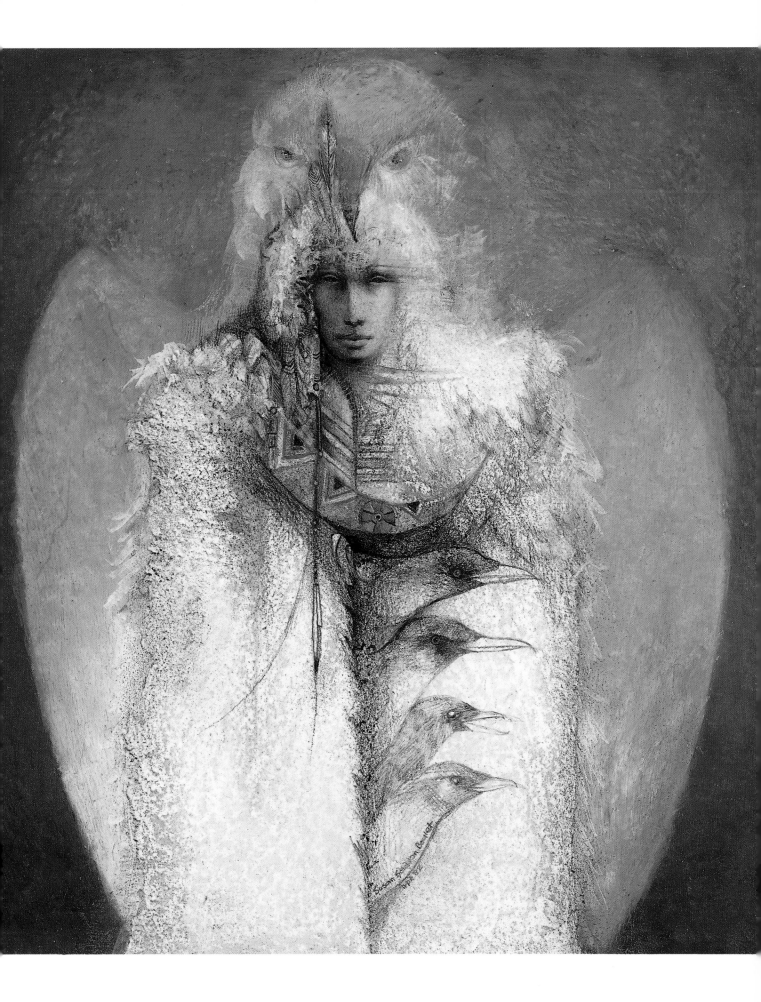

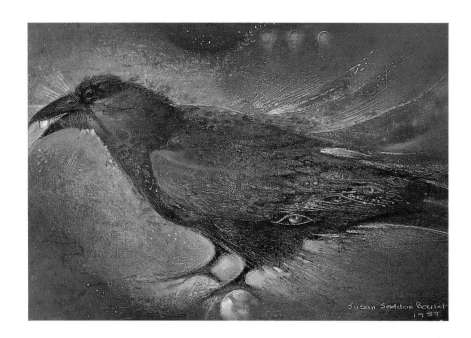

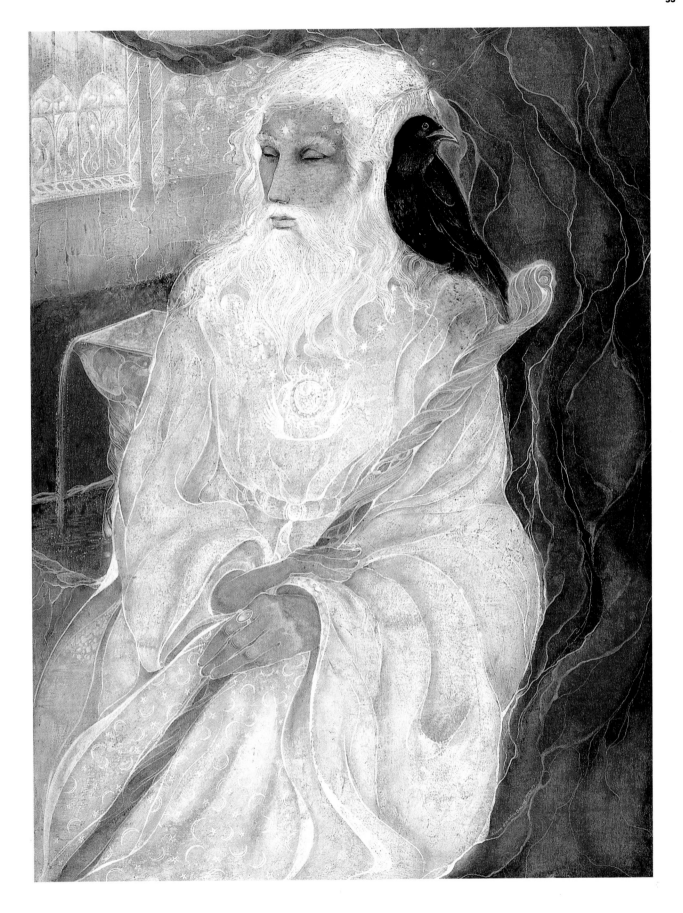

The Archmage with Osskil

Spirits
I can see

They will come to me
They will come down under a cloud
They will be my masters

I can see
They will walk in Raven town

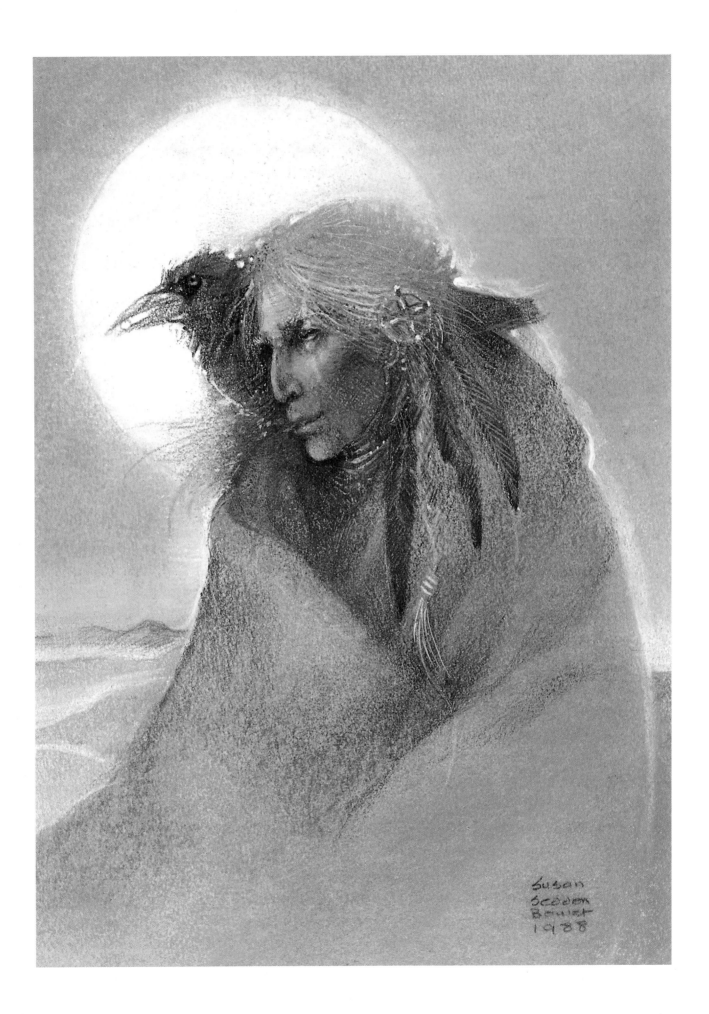

Susan
Seddon
Boulet
1988

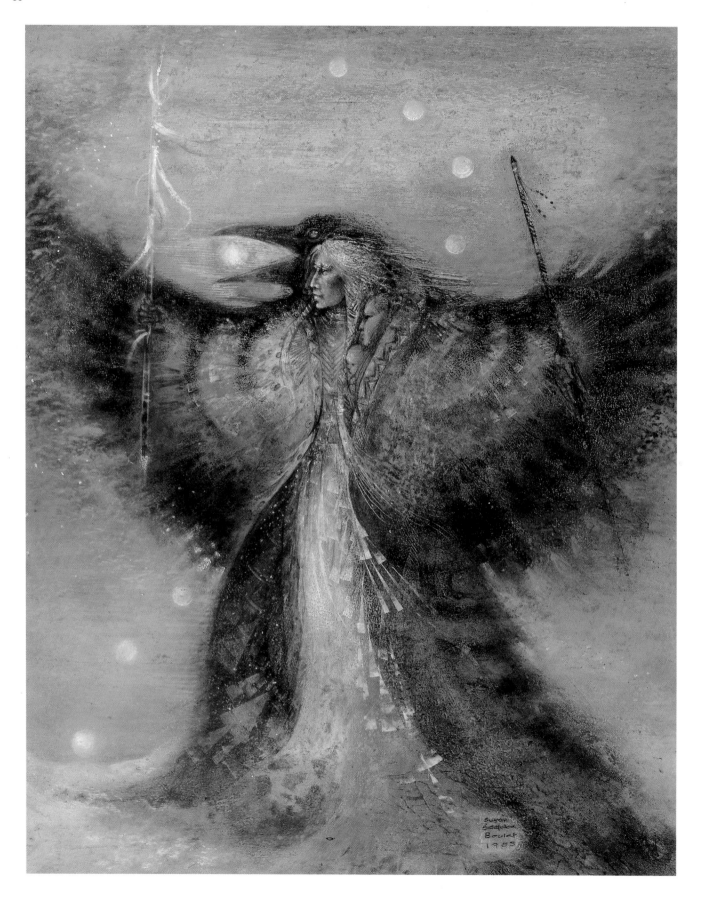

The Ancestor of the North

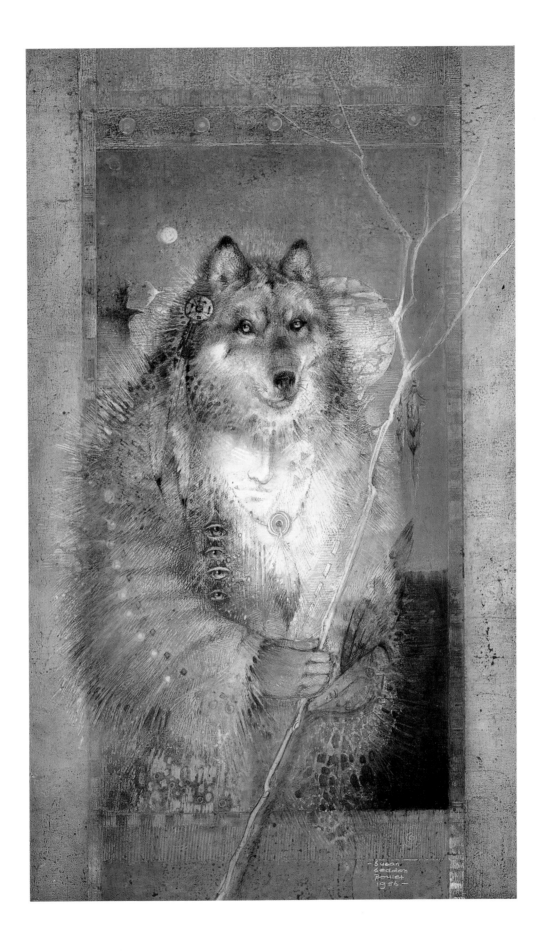

Grandfather Wolf

O, Kawas, come with wings outspread in the bright blue sky.

O, Kawas, come and give new life to us.

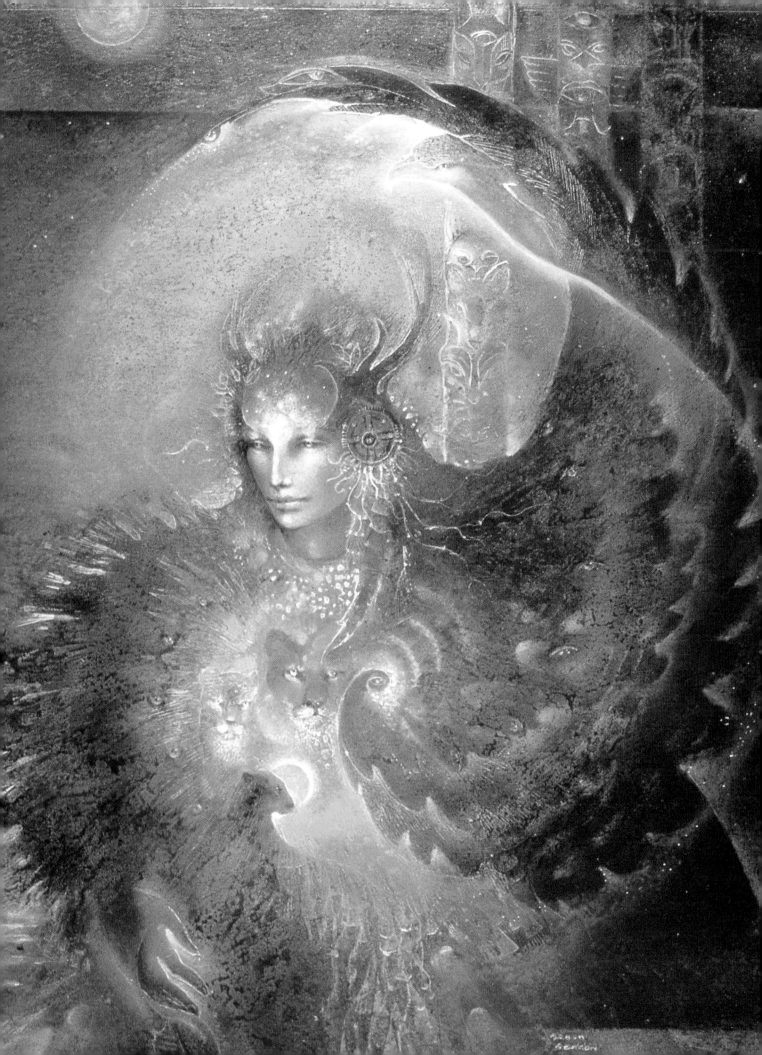

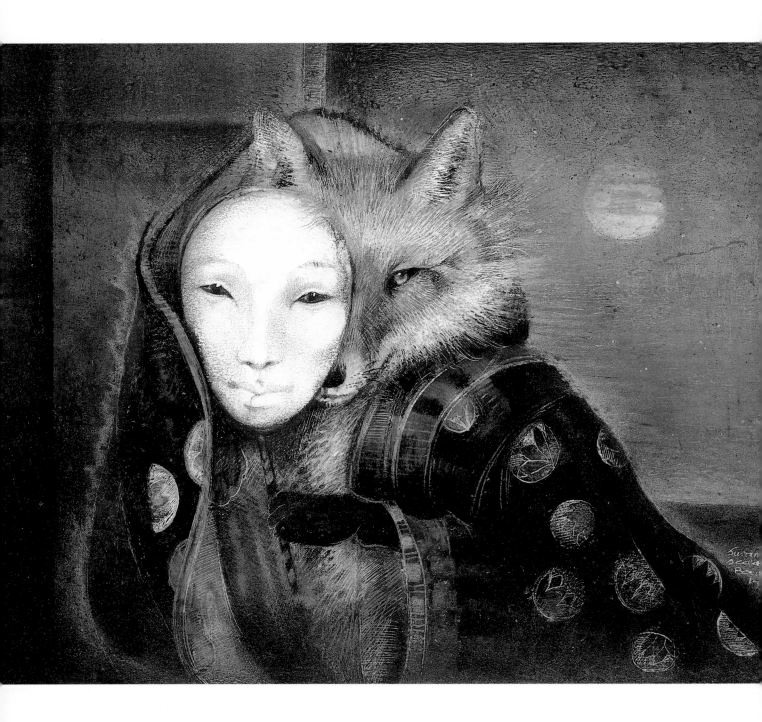

Fox Maiden

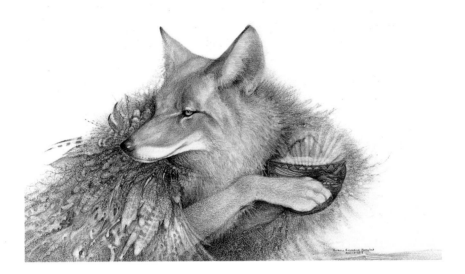

If a man is sick

I turn into a bear

the Great Bear of the First Creation

my fur is all white

but no polar bear

I'm the Bear of the First Creation

I lick my paws all over

seize hold of that man

squeeze him tight wherever it hurts him

then I blow all over his body

with my healing breath

the Spirit Breath of the First Creation

Dancing the Bear Dream

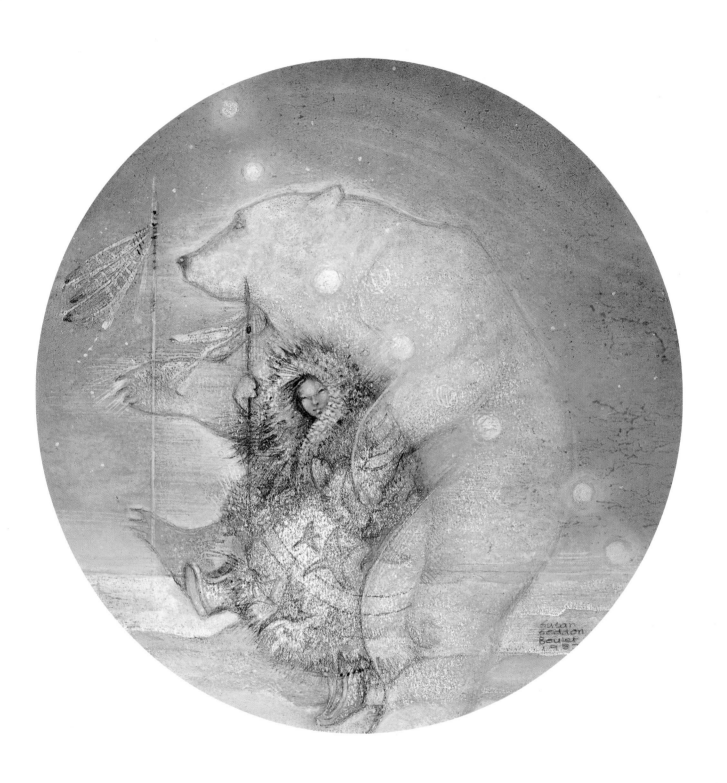

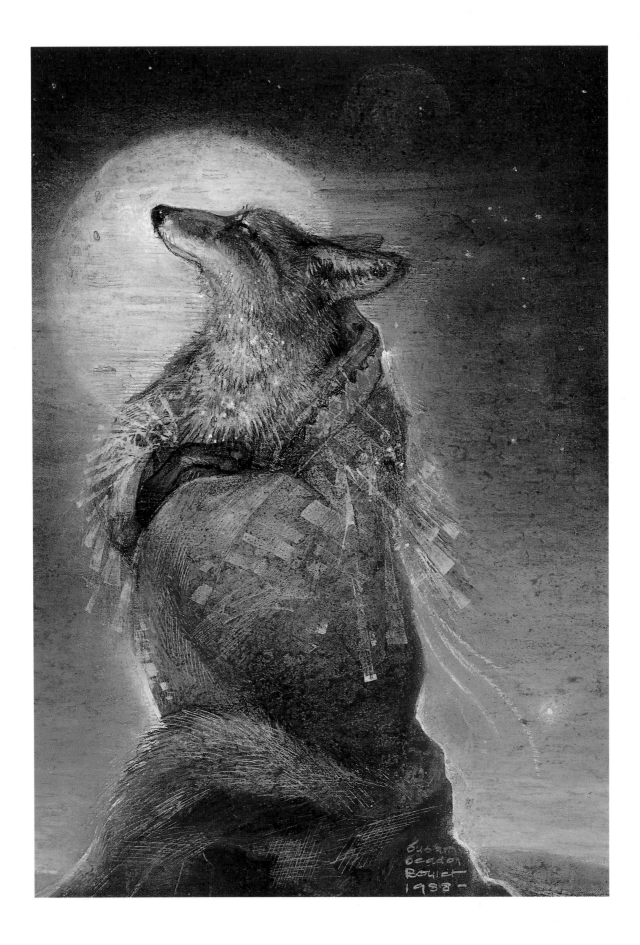

Coyote Woman Dreaming

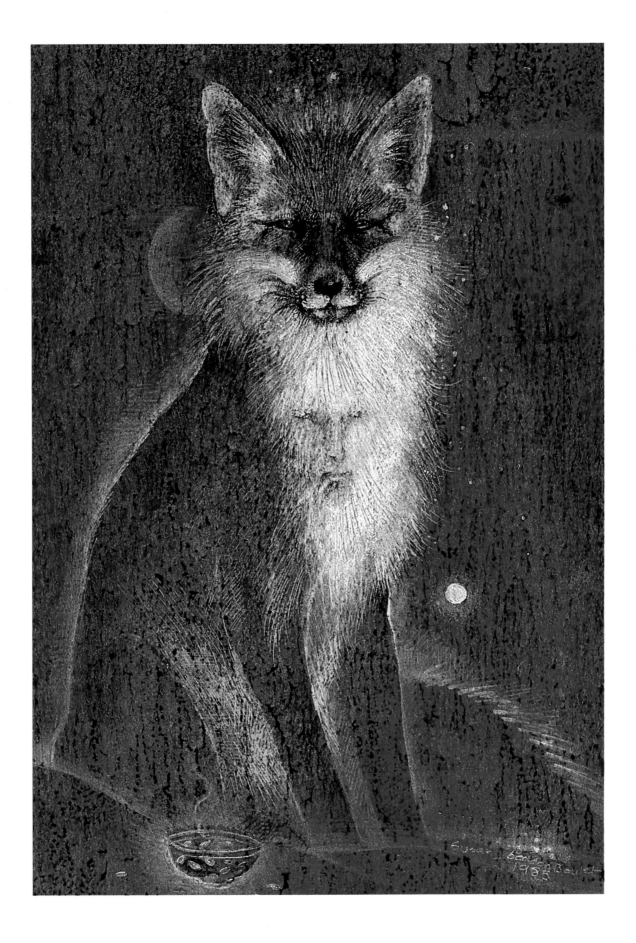

Inari

Just what did the voice of the spirit-chief
Say about wealth?
"The voice of the hummingbird will be
Heard on my head in the spring."
My spirit has gone as far
As the Nass's waters flow.

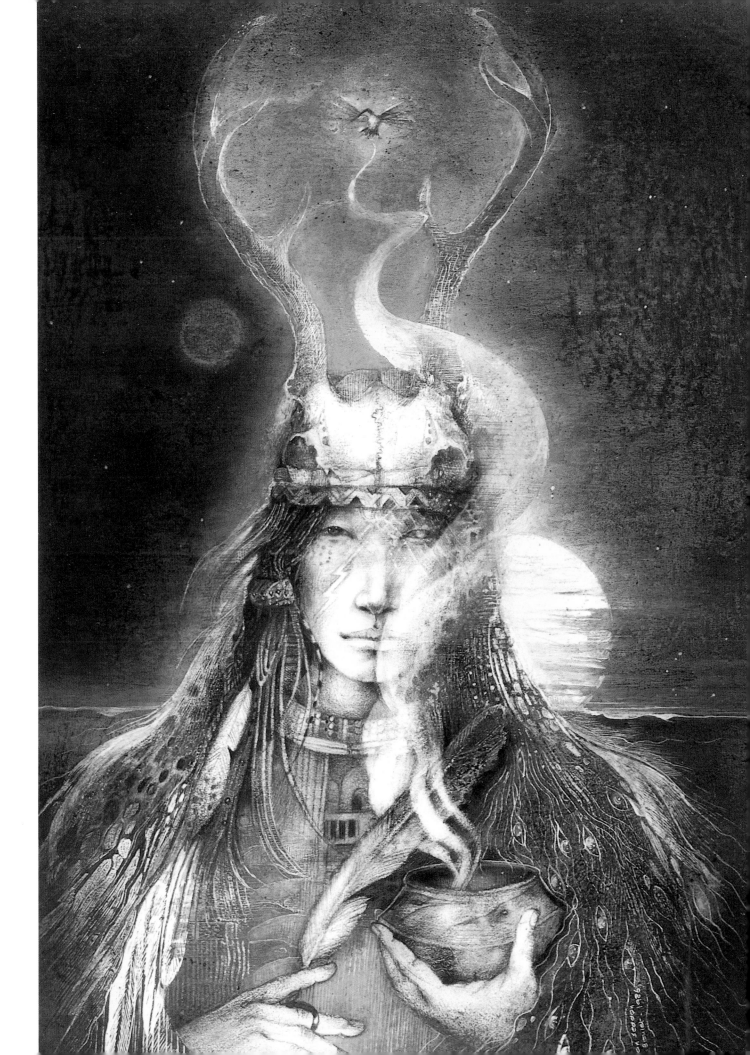

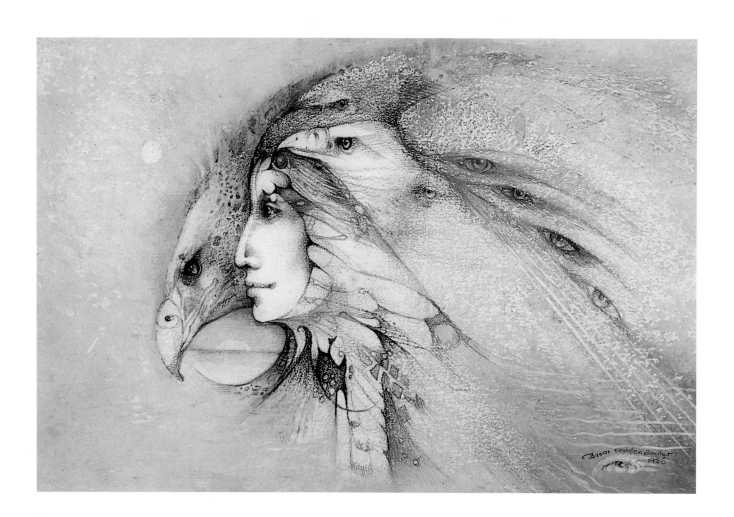

Eagle Woman

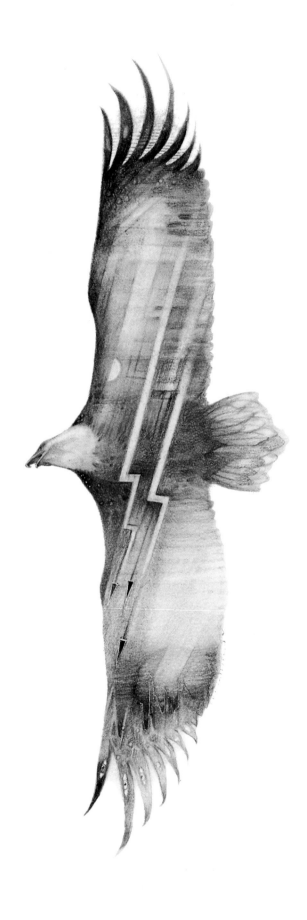

Eagle

Whu ! Bear !

Whu

Whu

So you say

Whu Whu Whu !

You come

You're a fine young man

You Grizzly Bear

You crawl out of your fur

You come

I say Whu Whu Whu !

I throw grease in the fire

For you

Grizzly Bear

We're one !

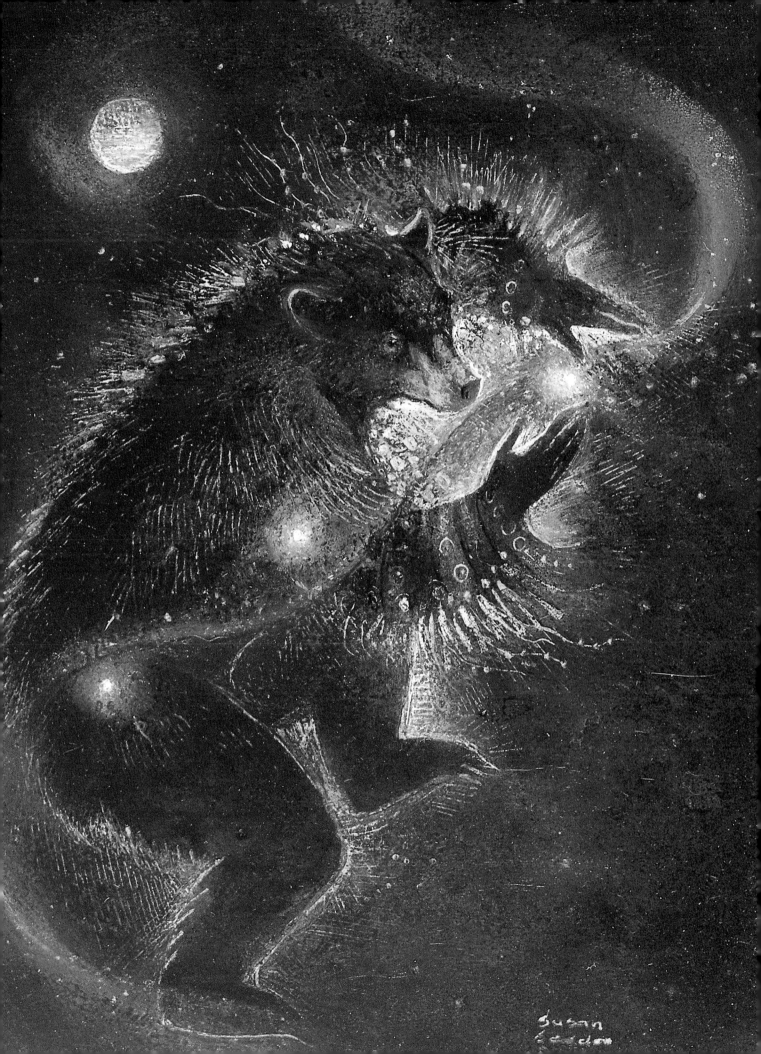

Through the air

As I move

Changing I go to a sacred place.

This is the way, going up

Little cloud me.

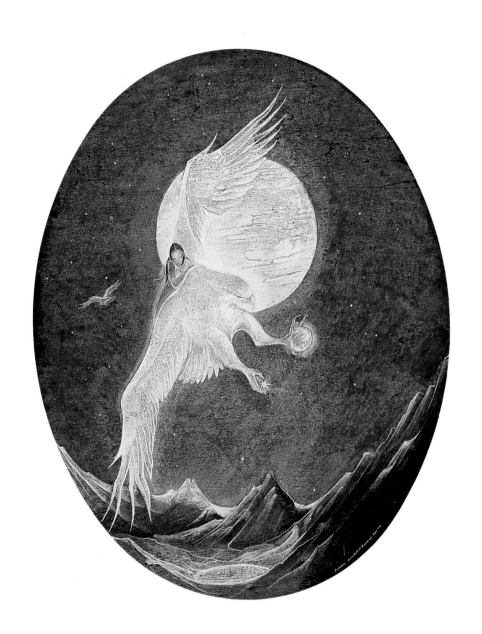

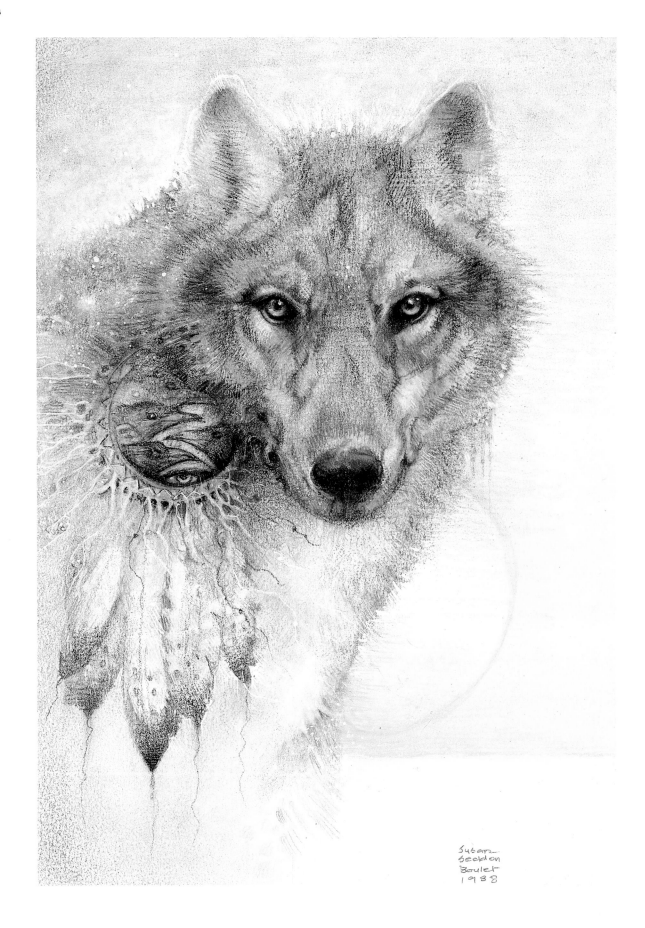

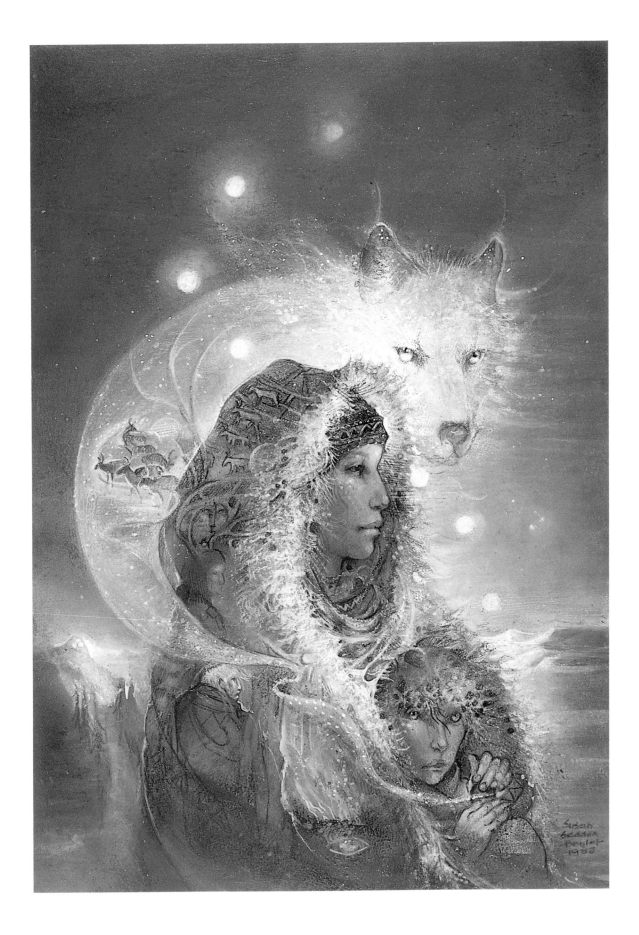

Reindeer People

Soon feeling the darkness,

Yolkai Estan formed a circle,

shaping it of turquoise and white shells.

Over this She held a rock of crystal,

held it until a fire burst forth,

a blaze that grew so hot, so bright,

that with the help of the Holy People,

White Shell Woman pushed it further and further away,

higher and higher into the spaces of heaven.

So it happened that Yolkai Estan,

She who had been born at the time of trouble,

She who had arrived attended by rainbows,

brought light to the Earth.

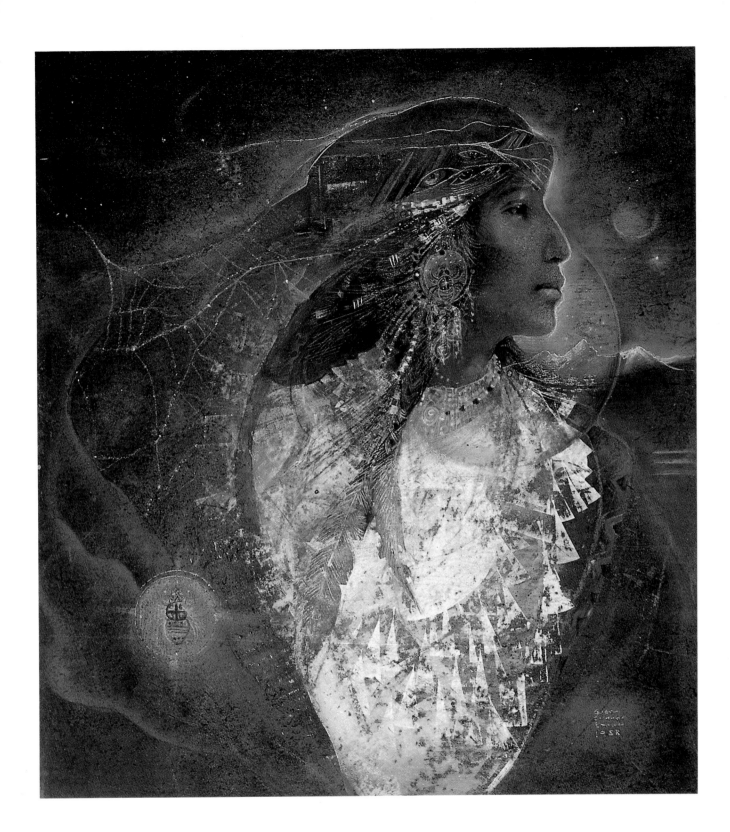

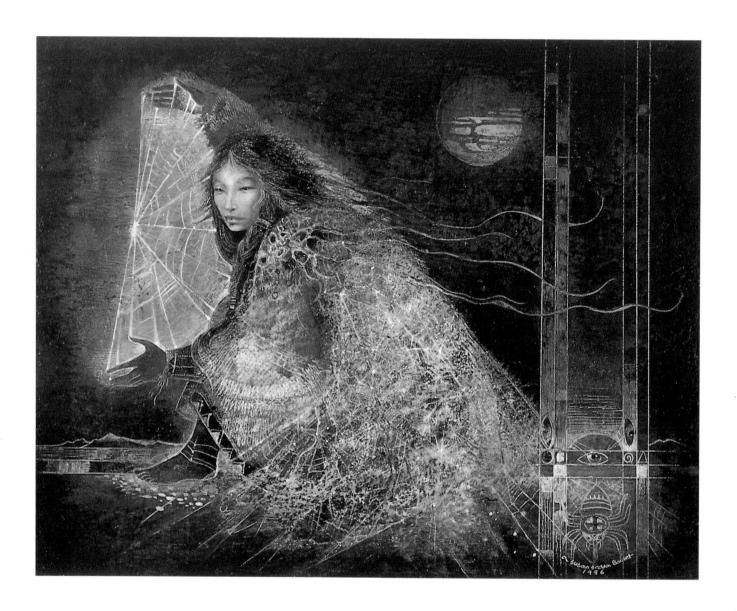

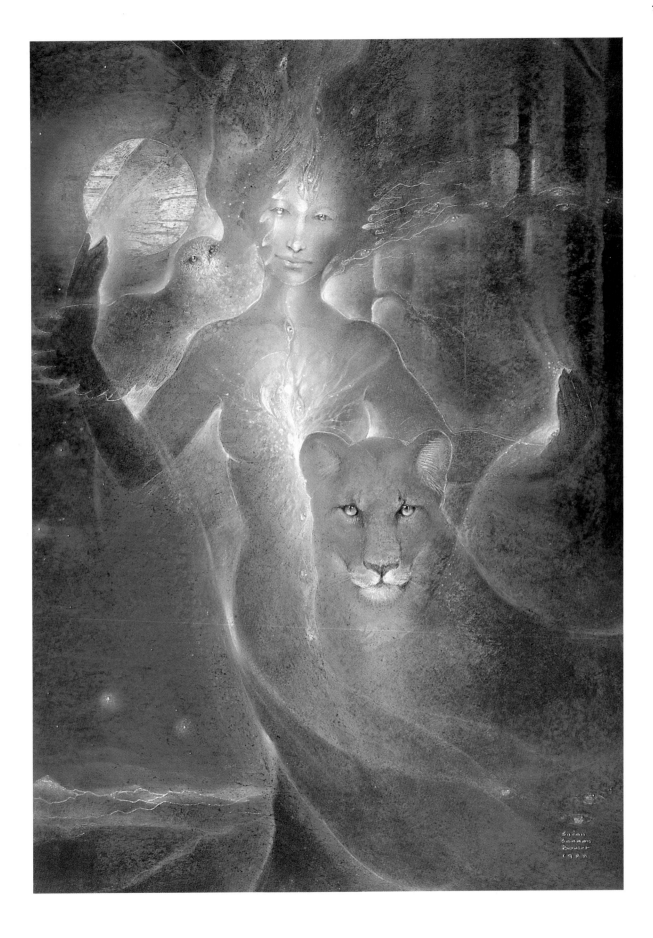

Lioness

Woman of the Southern Cross am I.

Woman of the first star am I.

Woman of the Star of God am I.

For I go up into the sky.

.

Woman who stops the world am I.

Legendary woman who cures am I.

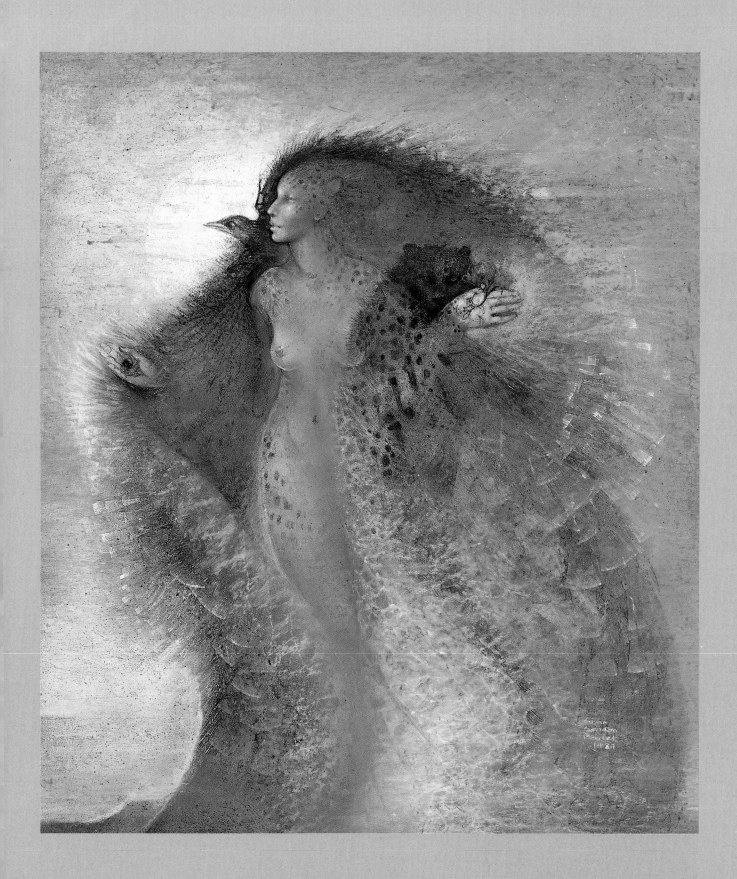

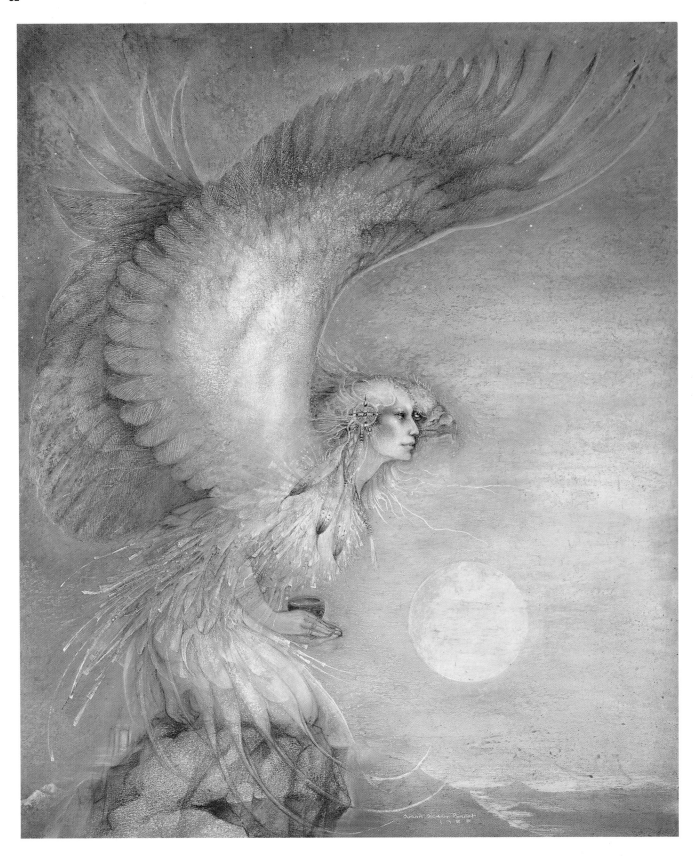

Eagle Woman

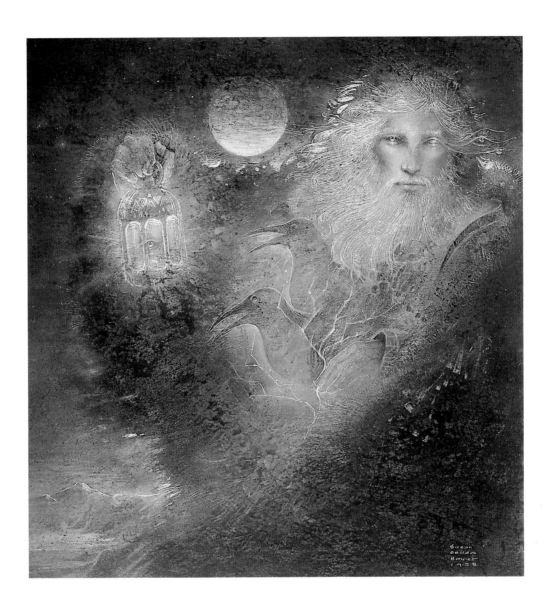

Where was I
I was invisible

the outer world
could not see me

the Outside Grandfather
could not see me

where was I
no one knew

the outer world
did not know me

the Outside Grandfather
did not know me

yes but he knows you
he knows you well

the outer world
pretends you're not

but the Outside Grandfather
he knows you

oh yes
he's moving toward you

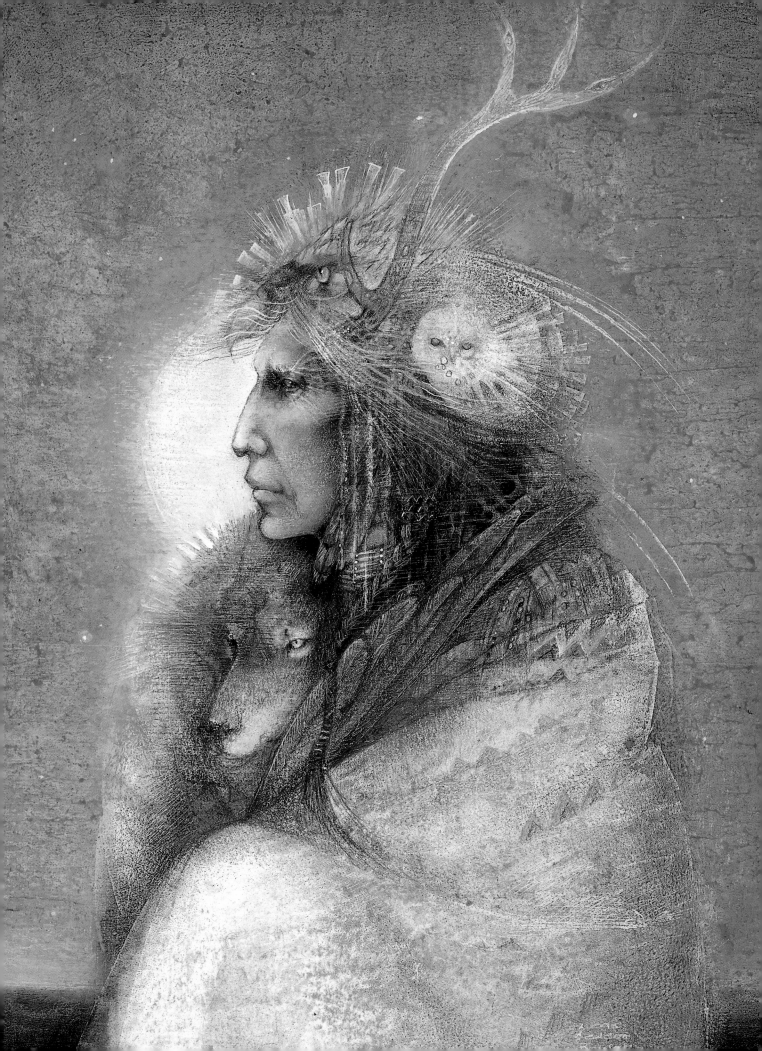

I will not forget these stones that are set

 In a round, on Salsbury Plains

Tho' who brought 'em there, 'tis hard to declare,

 The Romans, or Merlin, or Danes.

Myrddin (Merlin)

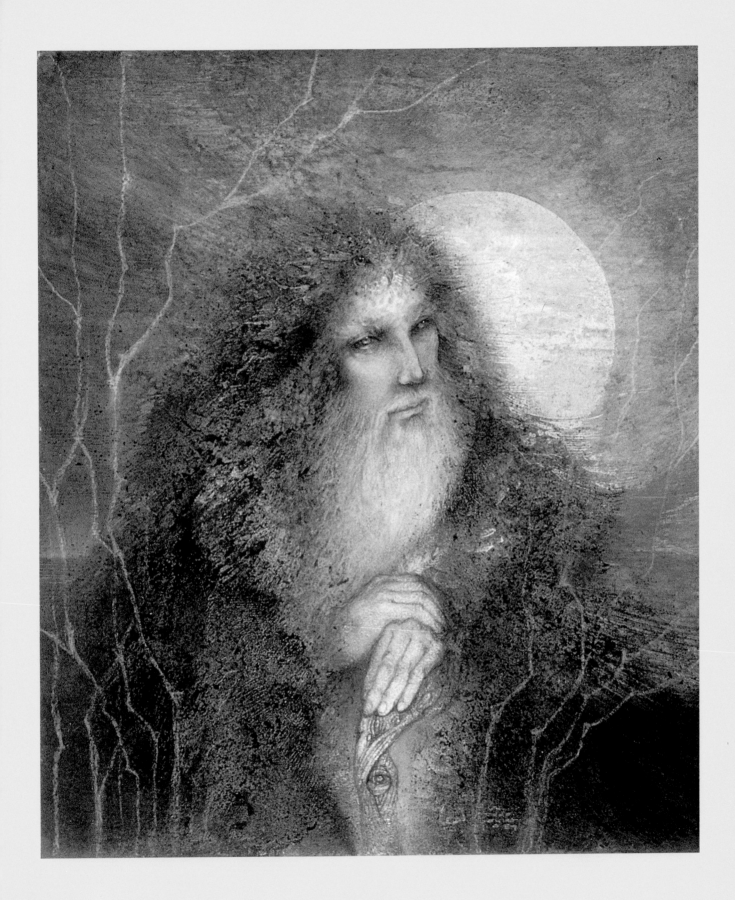

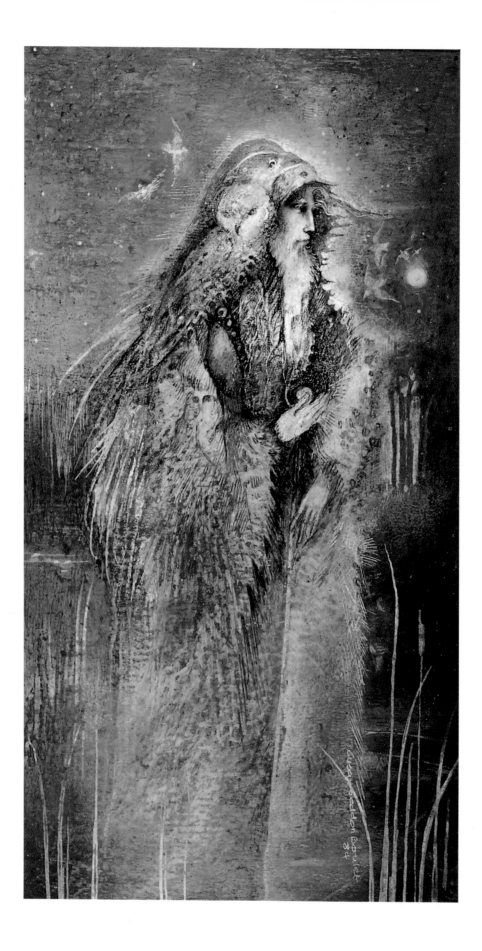

Seeker

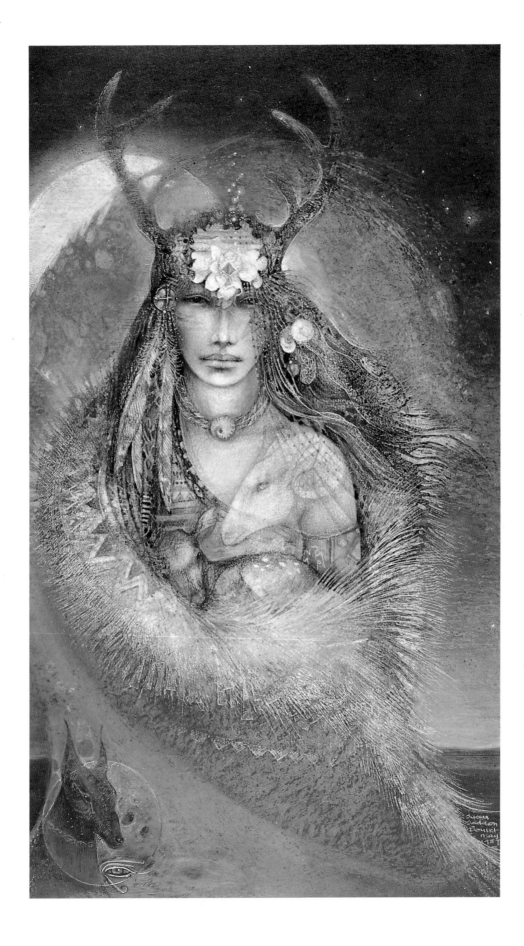

Deer Woman

At the centre of the Earth

Stand looking around you.

Recognizing the tribe

Stand looking around you.

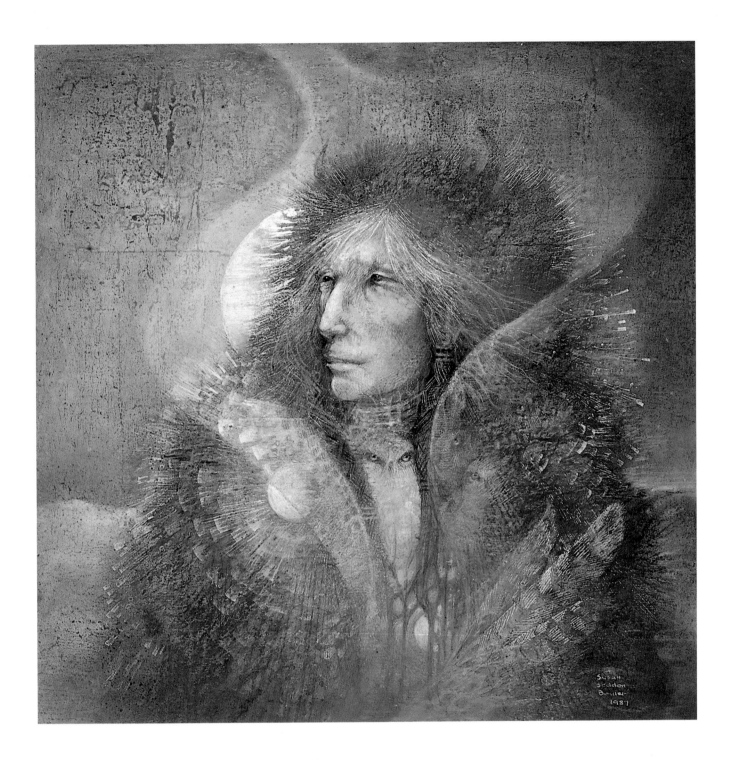

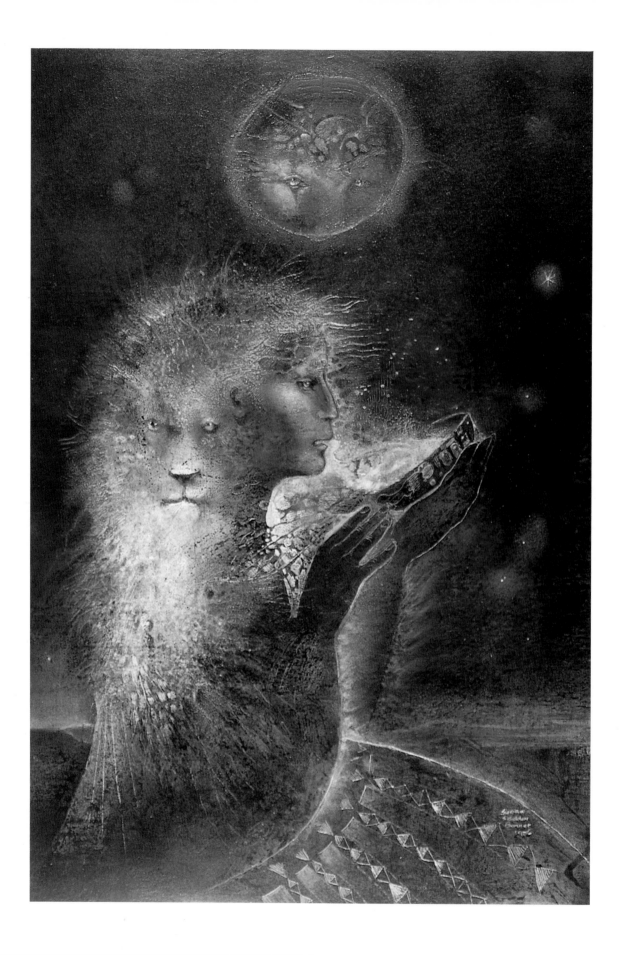

Delphic Cup

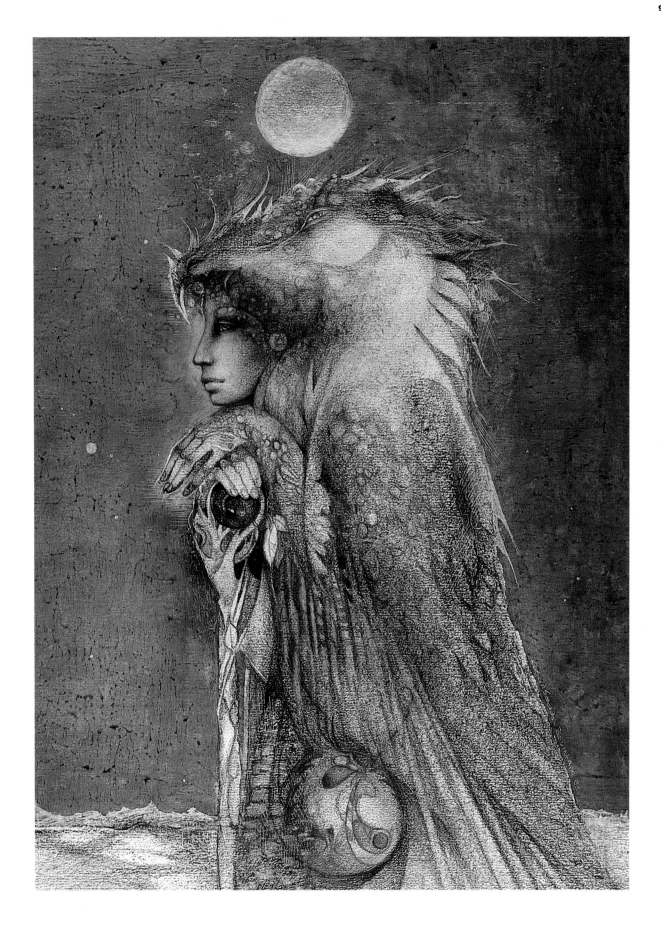

Dragon's Daughter

Oh Woman
Old Woman
up there
Zenith
into the wind
I call you
Old Woman
Oh-hoh

take out
your little knife
the copper one
you butcher with
Old Woman
you've got huge breasts

Oh Woman
Old Woman
scrape the sky
clear it up
make it good
all over
with your little knife
the copper one
scrape it down
good

Old Woman
Oh-hoh
I'm bending
over backwards
I fall down
I clap my hands
three times
to please you

I stuff my hand
the right one
in the left mitten
make it good

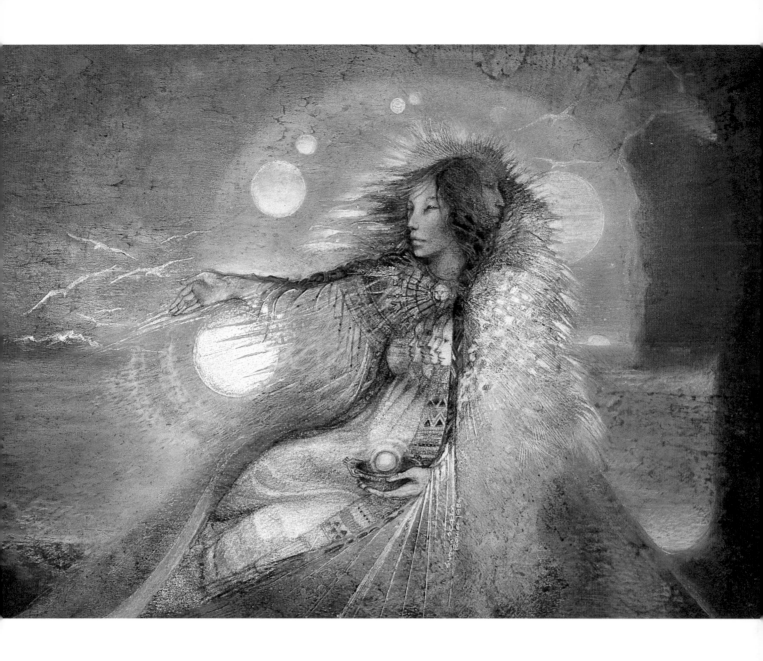

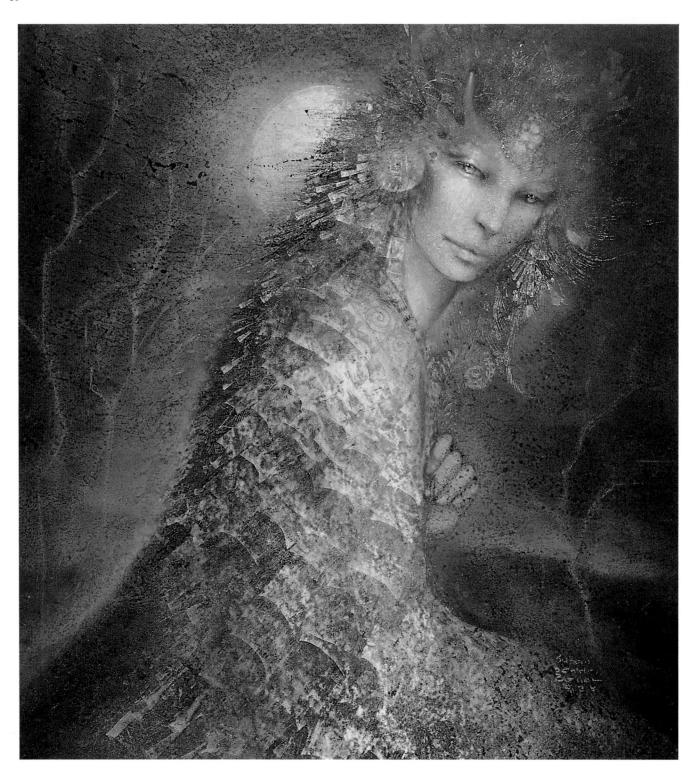

Deer Caller

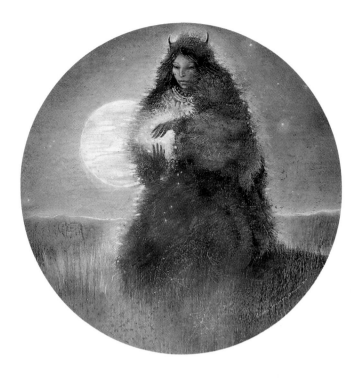

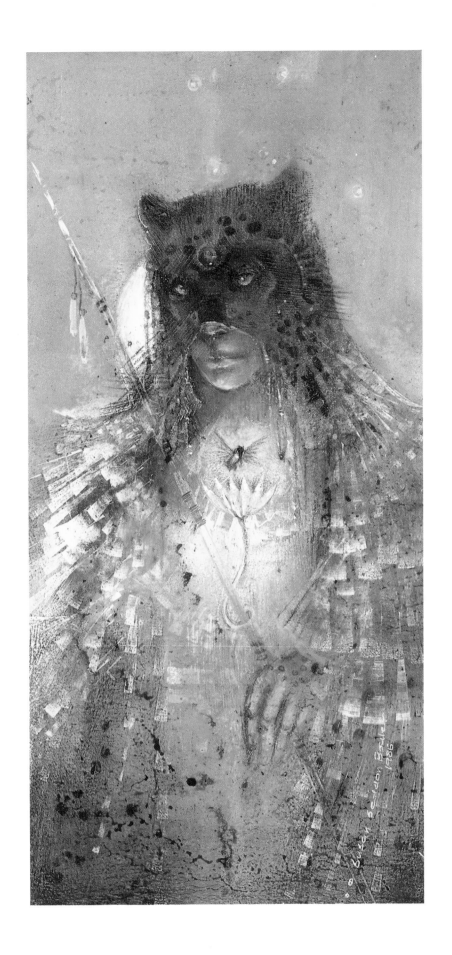

What I am trying to say is hard to tell and hard to understand… unless, unless…you have been yourself at the edge of the Deep Canyon and have come back unharmed. Maybe it all depends on something within yourself— whether you are trying to see the Watersnake or the sacred Cornflower, whether you go out to meet death or to Seek Life.

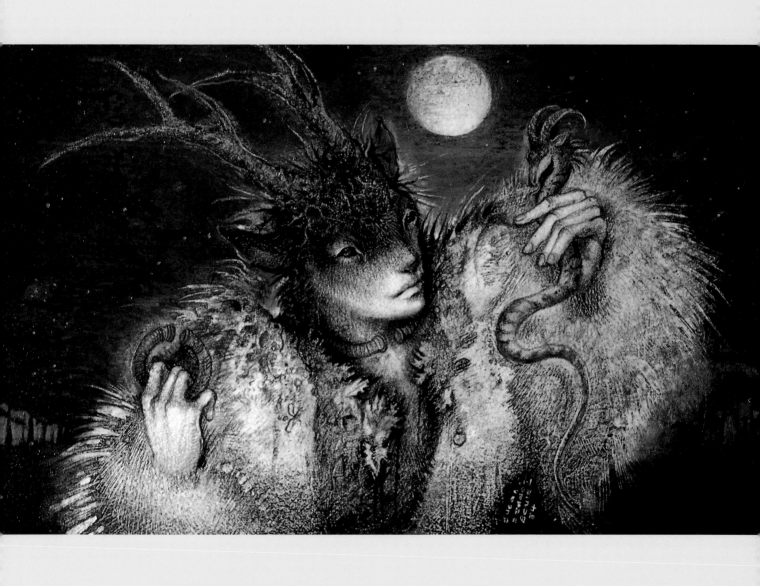

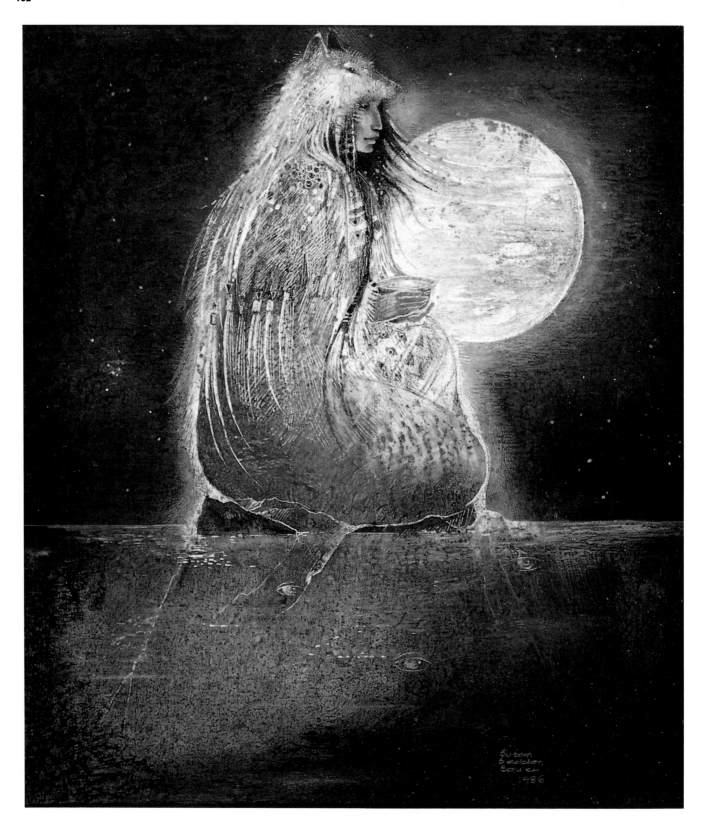

Wolf Moon

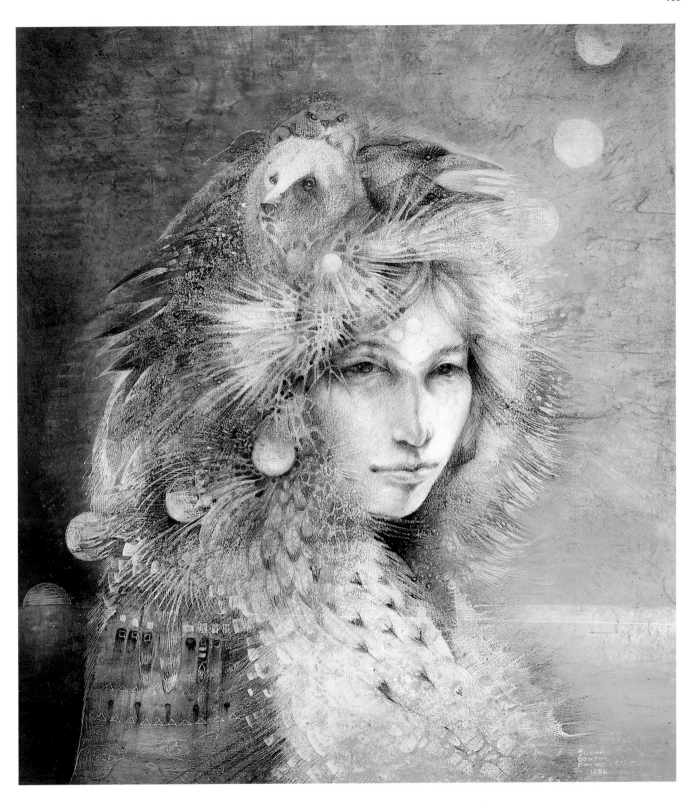

Seven Moons Passing

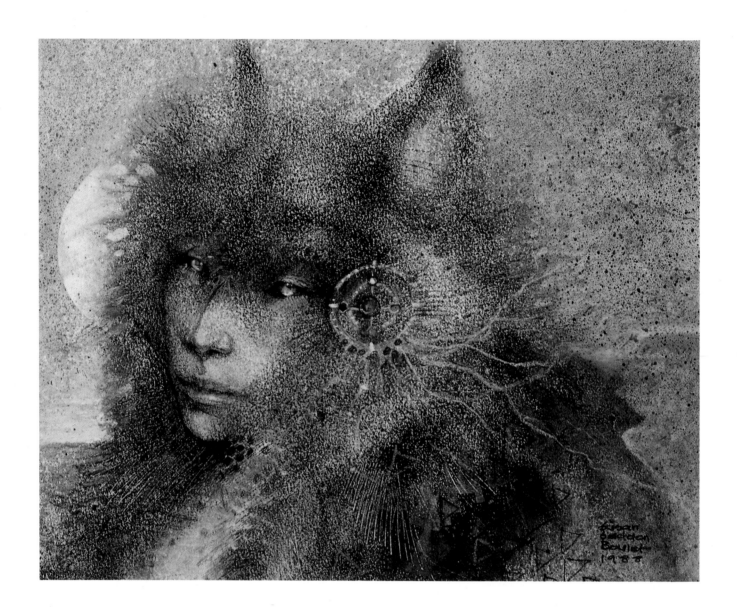

Wolf Child

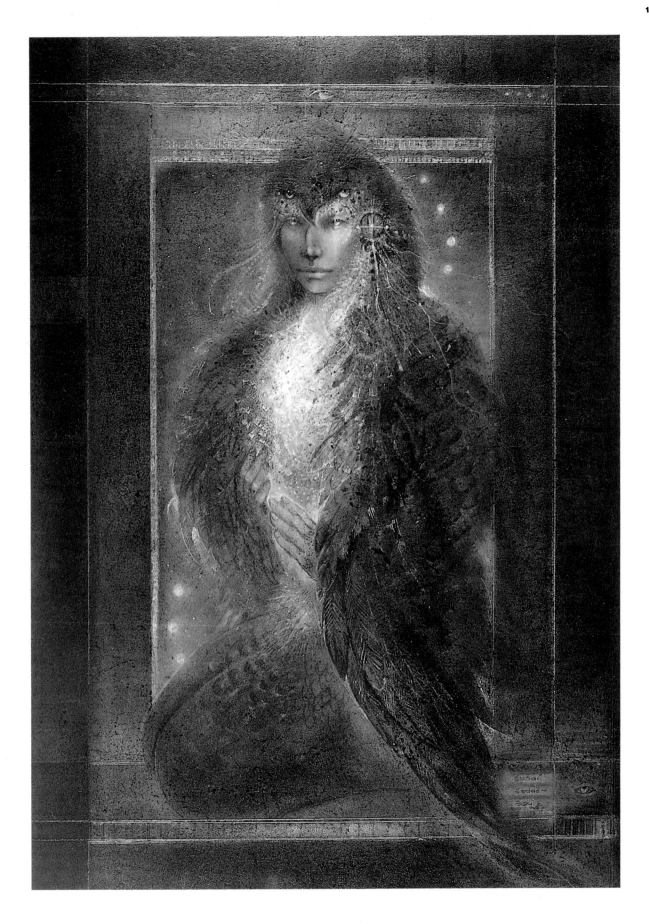

Night Hawk

While I stood there, I saw more
than I can tell, and I understood
more than I saw; for I was seeing
in a sacred manner the shapes
of all things in the spirit, and
the shape of all shapes as they
must live together like one being.

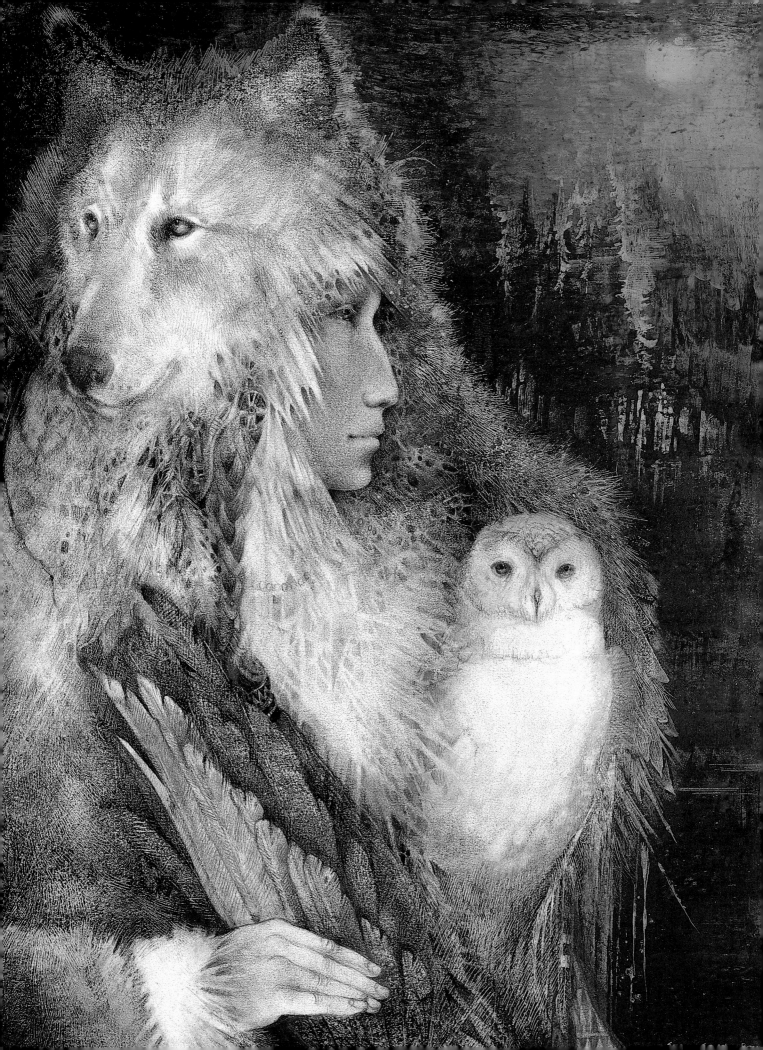

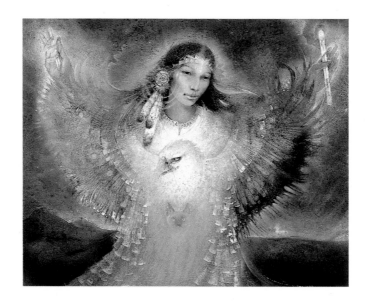

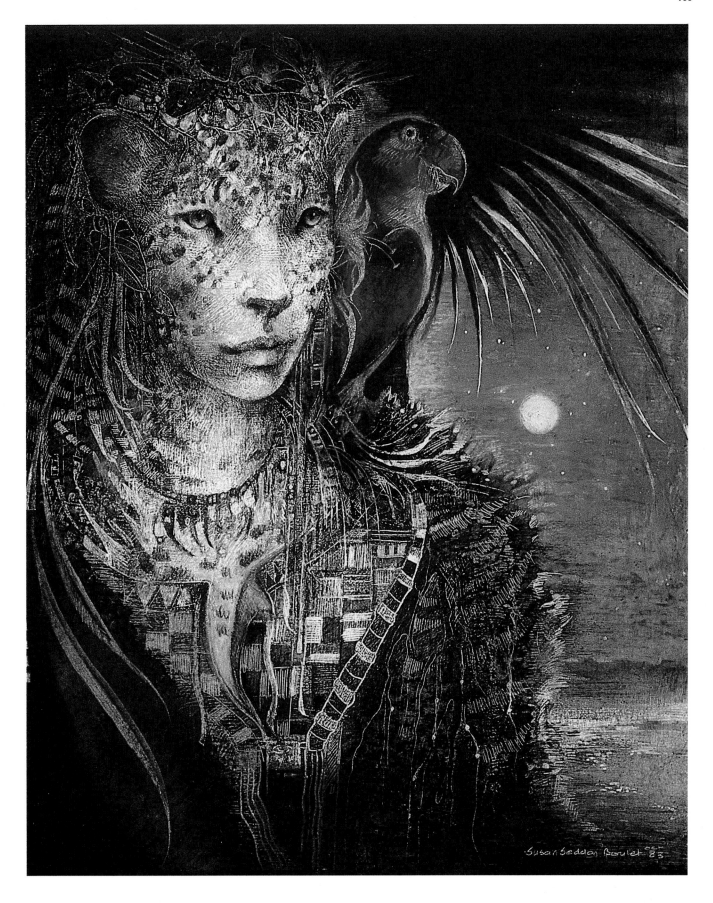

I am like a bear

I hold my hands waiting for the sun to rise.

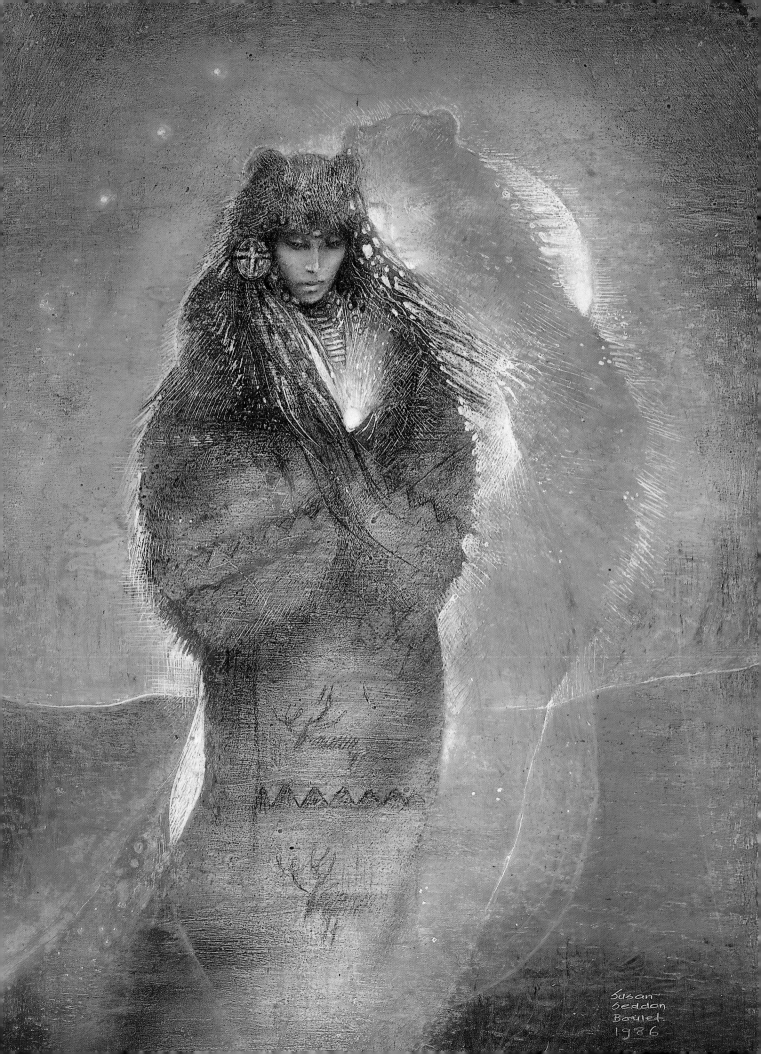

Susan
Seddon
Boulet
1986

If you want good dreams,
pray to the Grandmother Moon.
If you want to walk the good red
road, then rise before dawn
and pray the sun up.

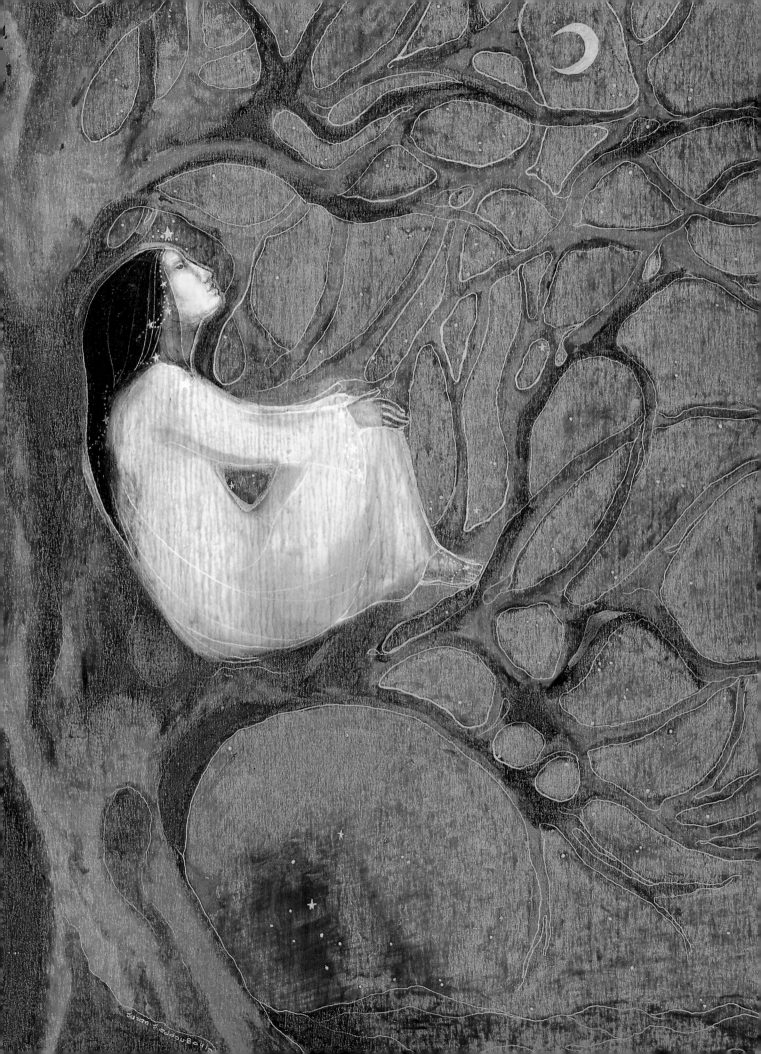

SUSAN SEDDON BOULET

Susan Seddon Boulet, born in Brazil
of British parents, was raised in South
America and educated there and in
Switzerland. She has received many
awards in northern California art exhi-
bitions, including the San Francisco
Art Festival. Her work can be found
in private collections throughout the
United States as well as in South America,
Europe and Asia. Ralph Metzner, psy-
chologist, educator and author of *Maps
of Consciousness*, says this about
Susan's work: "Susan Boulet's paintings
are vibrant, luminous visions, seemingly
channeled directly from the archetypal
realms of the psyche: gods, goddesses,
mythic heroes, nature spirits, androgy-
nous devas and elementals, sorcerers
and shamans with their power animals,
the wondrous play of children, mystical
journeys through numinous land-
scapes, the whimsical creatures of
folktales and dreams…forms, images
and symbols that evoke deep feeling
resonances of magical transformation
and the poignant mysteries of human
existence."

The literature on shamanism is extensive and growing weekly. Numerous studies of the shamanic practices of specific indigenous peoples are being issued from both alternative and traditional sectors of the publishing market. Much is being published on the application of shamanic knowledge to contemporary life and its attendant problems. For the reader who wishes to obtain a solid overview before determining specific fields of inquiry to pursue, we suggest the following books: Mircea Eliade's seminal (but dense) *Shamanism: Archaic Techniques of Ecstacy;* Ann Bancroft's *Origins of the Sacred,* especially her chapter "The Shaman and the Animal Powers"; Michael Harner's *The Way of the Shaman;* Joan Halifax's *Shamanic Voices* and *Shaman, The Wounded Healer;* Holger Kalweit's *Dreamtime and Inner Space: The World of the Shaman;* John Neihardt's *Black Elk Speaks;* and Carlos Castaneda's series of books on the Yaqui shaman, Don Juan, beginning with *The Teachings of Don Juan.*

If you wish to keep up with contemporary crosscurrents and discussion, we recommend you sample the monthly magazine *Shaman's Drum, A Journal of Experiential Shamanism* (P.O. Box 2636, Berkeley, CA 94702).

In addition to Susan Seddon Boulet's annual calendar, *The Path of the Shaman,* Pomegranate publishes a growing list of posters and notecards of her paintings. For a current list and information on how to obtain catalogs, write to Pomegranate at Box 808022, Petaluma, CA 94975.

SOURCES

Page 8 Washington Matthews. *The Mountain Chant, A Navaho Ceremony.* Fifth Annual Report of the Bureau of American Ethnology, 1883–84.

Page 16 **Zuni prayer (initiation rite), recorded 1932.** Ruth Bunzel. Bureau of American Ethnology Annual Report.

Page 21 **Black Elk (Ogalala).** John G. Neihardt. *Black Elk Speaks.* Lincoln, Nebraska, 1961.

Page 26 **Shamaness Hiwuna (Asiatic Eskimo).** David Cloutier. *Spirit Spirit, Shaman Songs.* Copper Beech Press, Providence, Rhode Island, 1980. Based on Waldemar Bogoras's *The Eskimo of Siberia.* Memoirs of the American Museum of Natural History, 1910–13.

Page 30 **Navaho.** Edward S. Curtis. *North American Indian,* 1907.

Page 36 **Chief Letakots-Lesa of the Pawnee Tribe.** Natalie Curtis. *The Indians Book: An Offering by the American Indians of Indian Lore, Musical and Narrative to Form a Record of the Songs and Legends of Their Race.* New York, 1907.

Page 42 **Black Elk.** See reference for page 21.

Page 50 *I-Ching, or Book of Changes.* Translated by Richard Wilhelm. Third Edition. Princeton, 1967.

Page 54 **Saxa of the Tlingit (Northwest Coast).** David Cloutier. *Spirit Spirit, Shaman Songs.* Copper Beech Press, Providence, Rhode Island, 1890. Based on John. R. Swanton's *Tlingit Myths and Texts.* Bureau of American Ethnology Bulletin 39, 1909.

Page 58 Alice Fletcher. *The Hako: A Pawnee Ceremony, Part II.* Bureau of American Ethnology, 1900–01.

Page 62 **Reindeer Chukchee (Asiatic Eskimo).** *Spirit Spirit.* Based on Waldemar Bogoras's *The Chukchee.* Memoirs of the American Museum of Natural History. Vol. XI, 1904–09.

Page 66 **Song of Hrywawyem of the Tsimshian tribe (Northwest Coast).** *The Tsimshian: Their Arts and Music.* Edited by Garfield, Wingert and Barbeau. Publication of the American Ethnology Society. Vol. XVII, New York, 1951.

Page 70 **Tlingit (Northwest Coast).** See reference for page 54.

Page 72 **Geronimo's Chant.** See reference for page 36.

Page 76 **Navaho.** Merlin Stone. *Ancient Mirrors of Motherhood.* Boston, 1984.

Page 80 **Maria Sabina, Mazatec shamaness (Mexico).** Joan Halifax. *Shaman: The Wounded Healer.* London, 1982.

Page 84 **Asiatic Eskimo.** See reference for page 26.

Page 86 Walter Pope. *The Salsbury Ballad,* 1676.

Page 90 Lakota Sun Dance Song. See reference for page 80.

Page 94 **Ritehrew (Asiatic Eskimo).** See reference for page 62.

Page 100 **An elder of the San Juan Pueblo.** V. Laski. *Seeking Life.* Austin, 1959.

Page 106 **Black Elk.** See reference for page 21.

Page 110 Frances Densmore. *Pawnee Music.* Bureau of American Ethnology, Bulletin 93, 1929.

Page 112 **Rolling Thunder, Cherokee medicine man,** as recounted by James Swan.